IMAGES of America
HOUSTON'S RIVER OAKS

On the Cover: This beautiful Georgian gateway, which leads into River Oaks, set the tone for the neighborhood. John F. Staub designed the stucco piers, and the wrought-iron light fixture and grillwork atop were produced by Emanuel W. Sturdivant, president of Lighting Fixture Company, Inc. (Courtesy of the Houston Metropolitan Research Center.)

IMAGES of America
HOUSTON'S RIVER OAKS

Ann Dunphy Becker with George Murray

Copyright © 2013 by Ann Dunphy Becker with George Murray
ISBN 978-0-7385-9669-3

Published by Arcadia Publishing
Charleston, South Carolina

Printed in the United States of America

Library of Congress Control Number: 2012953542

For all general information, please contact Arcadia Publishing:
Telephone 843-853-2070
Fax 843-853-0044
E-mail sales@arcadiapublishing.com
For customer service and orders:
Toll-Free 1-888-313-2665

Visit us on the Internet at www.arcadiapublishing.com

To my family: Dan, Charles Dain, and Mary Allison Becker

Contents

Acknowledgments		6
Foreword		7
Introduction		8
1.	1920s: Country Living in River Oaks	9
2.	1930s: Anyone Can Afford to Live Here	43
3.	1940s: The War Years	71
4.	1950s: The "Happy Days" Decade	87
5.	1960s: A Changing World	113
Index		127

Acknowledgments

I would like to acknowledge the following people who were involved in this project: Sarah Rothermel Duncan for her continued support and involvement in all my history-related endeavors; George Murray for helping get this project off the ground and his enthusiastic encouragement right up until the last word was written; Francita Stuart Ulmer for her incredible editing and writing ability, expertise in the historical aspect of the neighborhood, and her wonderfully biographical introduction; Marian Fowlkes Minniece for her intuitive direction and guidance; Joan Potter Cullinan Hazelhurst for giving me open access to Hugh Potter's papers; Joan Blaffer Johnson for her energy, assistance, and insight; Kirk Farris, Steve Griffin, Jim Fisher, Jim Olive, Story Sloane III, Debra Harwell, and Talbot Cooley for their immediate responses to e-mail, advice, and imagery; Kameron Searle for his superior contributions to the book; and Sarah Jackson, Joel Draught, Tim Ronk, Wallace Saage, and Lee Pecht, Houston's finest archivists and curators.

I would like to thank the following contributors to the book in order of appearance: Susan Clayton Garwood, Alice Picton Craig, Judge Paul Pressler, Lucile Mellinger Harris, George Strake Jr., Louis F. Rothermel II, Jeanie Kamrath Gonzales, Maria Burke Butler, Michaelene "Miki" Lusk Norton, Maurice McAshan, James Brill, Sue Trammell Whitfield, Barry Moore, Lise Liddell, Sue and Paul Gervais Bell Jr., Jill Anderson Kyle, Tom Cain, Rhetta Moody McAlister, Bebe Moody Boone, Denman Moody Jr., Carolyn and Dr. Carlos Robert Hamilton Jr., Joan King Herring, Sue Brooks Green, Laura Cochran Savage, Dorothy Knox Howe Houghton, David Purdie, Verlinde Hill Doubleday, and the River Oaks Property Organization, Inc., Gary Mangold and especially Judy Moses.

Foreword

In 1924, the area of Houston that was to become River Oaks was located west of downtown Houston and was full of timber and scattered farms. Houston businessmen shaped the future of our great city, and the founders of River Oaks stylized the neighborhood in a pattern already in use by other cities: the garden suburb. River Oaks was planned so carefully that it has retained the excellence in community and aesthetics intended by Hugh Potter and Will and Mike Hogg.

The first part of this book gives a photographic account of the building of this subdivision. The second part introduces the lifestyle as exemplified by some of the families who lived here from the beginning in 1924 until 1970. Unless history is written, it will be lost. There are many important families that were not mentioned because of a finite amount of time and space, but by the end of this historical journal, the reader will have experienced River Oaks and the atmosphere in which its residents lived.

—Ann Dunphy Becker

Introduction

When my parents moved to River Oaks in 1930, people wondered who would want to drive to town in the morning facing the sun on a narrow two-lane road that curved around the bends of Buffalo Bayou and return from work facing the afternoon glare when there were houses available in established neighborhoods like North and South Boulevard, Riverside, or Braeswood. The answer was that the creators of River Oaks, the Hogg brothers and Hugh Potter, were visionaries as well as practical businessmen. Because Houston lacked zoning (and still does), the developers wisely understood that homeowners would benefit from a set of restrictions to govern the subdivision that they themselves would administer and enforce.

When the Hogg family and Hugh Potter organized River Oaks, they intended to create a development of outstanding quality. They hired a nationally recognized design firm, Hare and Hare of Kansas City, Missouri, to draw the plans for their subdivision. These included beautiful wide esplanades down the center of major streets like Kirby Drive and River Oaks Boulevard. They would be planted with boxwood hedges enclosing rose bushes. On other streets, like Stanmore, Chevy Chase, Del Monte, and Pine Valley Drives, there would be small green parks where children could play safely. River Oaks was not intended to be an exclusive enclave for only the wealthy. Lots were of varying sizes and prices.

This carefully researched and well-thought-out plan laid the foundation for River Oaks to become the premier residential neighborhood that it remains today. An important part of the original plan was a provision for a public school of high standards. In cooperation with the Houston School District, Miss Hogg helped to establish River Oaks Elementary School. The district officials, Hogg, and a committee of mothers chose Eva Margaret Davis as the first principal. Davis was a Columbia University graduate who had studied under John Dewey, a nationally recognized educator. Harry Payne, a highly regarded architect of elementary school buildings, designed the classic structure that, with additions, still stands.

These amenities, together with strong feelings of community among the first residents of River Oaks, led my parents to choose 2510 Inwood Drive. I formed close childhood friendships there that have lasted a lifetime. I still live only one street over from the home where I was brought from Houston Baptist Hospital as a newborn in May 1931.

I first met Ann Dunphy Becker when she was assisting my childhood friend and neighbor Adelaide Scott Smith in research that resulted in a Texas State Historical Marker being placed in Glenwood Cemetery in 2005 to honor Adelaide's ancestor Gustav August Forsgard.

This book, written by Ann and encouraged by longtime resident businessman George Murray, tells interesting stories of families who were part of River Oaks during the first 50 years of its now 87-year history.

—Francita Stuart Ulmer
Member, Harris County Historical Commission 1975–2012

One
1920s
COUNTRY LIVING IN RIVER OAKS

River Oaks was developed as a residential subdivision in the early 1920s. The ownership of the property can be traced to June 4, 1825, when Allen C. Reynolds, a New York native, received a league of land (4,428 acres) from the Mexican state of Coahuila and Texas as part of the second Stephen F. Austin colony. His league was defined in the legal agreement with language such as "lying on the right bank of the arroyo called Buffalo Bayou, adjoining and north of a tract of John Austin; and from a pine tree 8 inches" and "a line was drawn south 6881 versa to an earth mound, thence west 4000 versa to another earth mound." A *vara* (in the deed, "versa") is a unit of length equal to 33.5 inches. River Oaks was built on the A.C. Reynolds league.

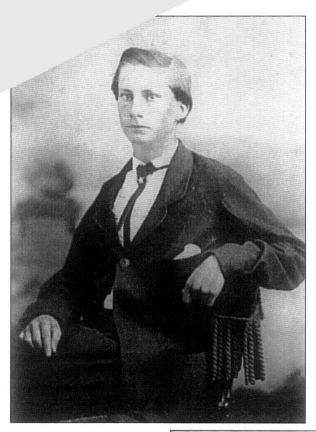

The land remained undeveloped aside from a few farms until 1923, when Thomas W. House Jr. (pictured), Congressman Thomas H. Ball, and A.C. Guthrie agreed that Houstonians had need of a new country club and golf course. They purchased 350 acres at $500 each to the west of the city of Houston and formed a company called Country Club Estates. (Courtesy of SallyKate Marshall Weems and Steve Griffin.)

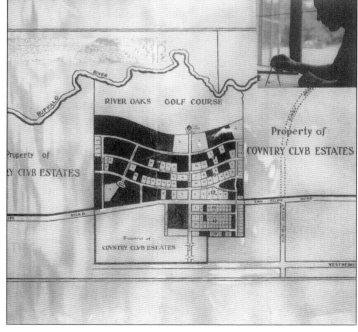

The main focus of their endeavor was a golf course, and this early map shows the initial layout of the streets just south of the proposed clubhouse. The streets in Country Club Estates were named for famous golf courses like Chevy Chase, which is in a Maryland suburb of Washington, DC; Inwood, on Long Island outside of New York City; Del Monte, in Monterrey, California; and Sleepy Hollow, in Scarborough-on-the-Hudson, New York. (Courtesy of Joan Potter Cullinan Hazelhurst.)

Despite those who doubted the viability of a club way out in the country at that time, T.W. House and his friend Thomas H. Ball (pictured), together with several other men, began selling club memberships. Within eight months, 300 memberships were sold, and each member received one share of stock in Country Club Estates Company. The main road to the country club was named Ball Avenue. (Courtesy of Joan Potter Cullinan Hazelhurst.)

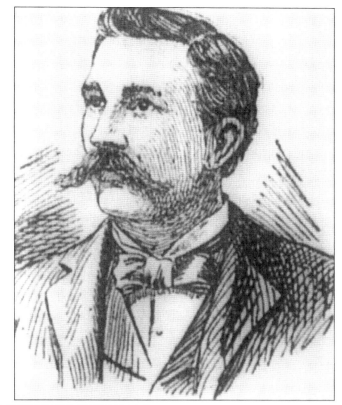

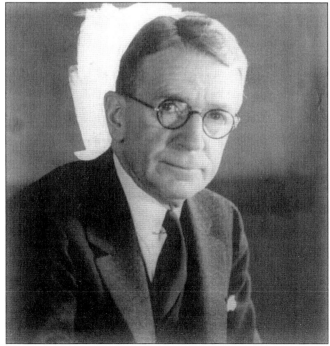

At the same time, a group of investors led by lumberman Junius W. Reynolds organized the River Oaks Country Club and retained civil engineer Herbert A. Kipp (pictured) to lay out the subdivision. Kipp was then made vice president. In 1924, Kipp's subdivision plat was filed and club members were offered a pre-sale of the lots to be developed. (Courtesy of Houston Metropolitan Research Center.)

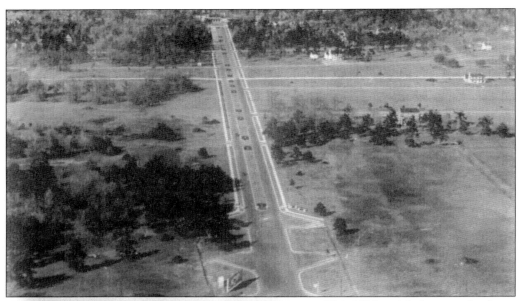

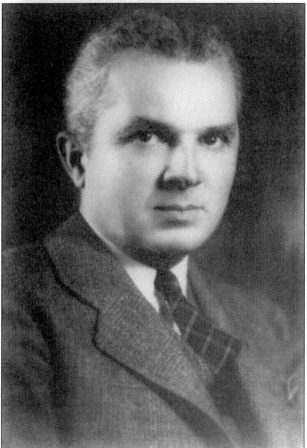

This 1923 aerial photograph of River Oaks Boulevard has San Felipe Street at the bottom. Only native trees are visible, and the densely wooded area surrounding the golf course is evident. A billboard advertising the subdivision is visible in the lower left of the picture, and landscaping has begun on the esplanade down what was then called Ball Avenue, after Congressman Thomas H. Ball. County Club Estates hired architect John F. Staub (left) to design the original two-story Spanish Revival clubhouse. Arriving in Houston in 1921 to oversee a construction project for New York architect Harry T. Lindeberg, Staub decided to stay and in 1923 formed another company. He is revered as one of America's foremost residential architects. Many of his beautiful creations can be seen in River Oaks today. He designed many residential homes in River Oaks, including his own, located at 3511 Del Monte Drive, where his grandson Peter Staub Wareing now lives. (Both, courtesy of Joan Potter Cullinan Hazelhurst.)

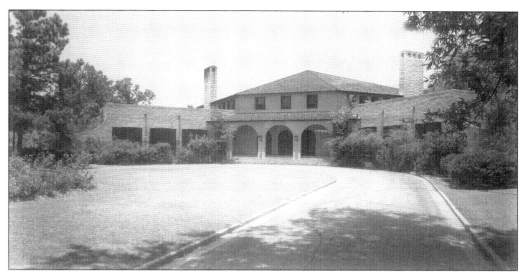

This is the Spanish Revival River Oaks Country Club building as designed by Staub in 1923 for Tom Ball, T.W. House, and A.C. Guthrie. (Image copyright Story Sloane's Gallery.)

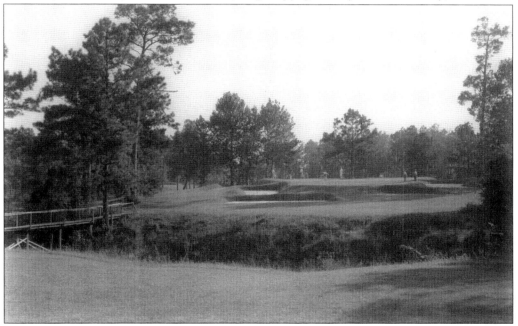

Kenneth Womack and William Stamps Farish, who had invested in the Country Club Estates Company development, knew Staub when he worked for Lindeberg on their houses in Shadyside. They gave Staub the contract for the country club, which was his first individual project after he decided to stay in Houston to open his own office. The country club was built south of the golf course previously designed by Donald Ross. This was a masterpiece in combining greens that would entertain and delight with the beautiful landscape. An example of Ross's usage of natural attributes is this rustic bridge, which was crossed to complete the fourth hole. Golfer Jack Nicklaus observed about Ross, "His stamp as an architect was naturalness." (Courtesy of Joan Potter Cullinan Hazelhurst.)

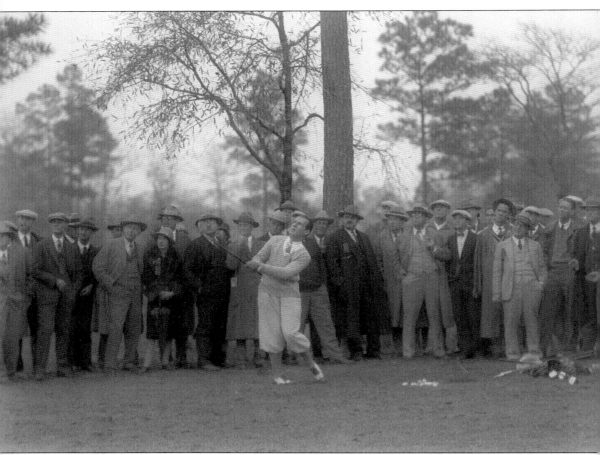

Country Club Estates Company was careful to hire the top people available in their field. This picture shows the beauty of the River Oaks Golf Course. Scottish-born Donald Ross was the greatest golf course architect at that time and was hired in 1923 to design the 182-acre, 18-hole golf course. Ross was famous for his test of the perfect course. This test called for long and accurate tee shots, accurate iron play, precise handling of the short game, and consistent putting. These activities should be called for in a proportion that would not permit excellence in any one department to largely offset deficiencies in any other. During his career, Ross designed more than 400 courses in the United States but only two in Texas. (Image copyright Story Sloane's Gallery.)

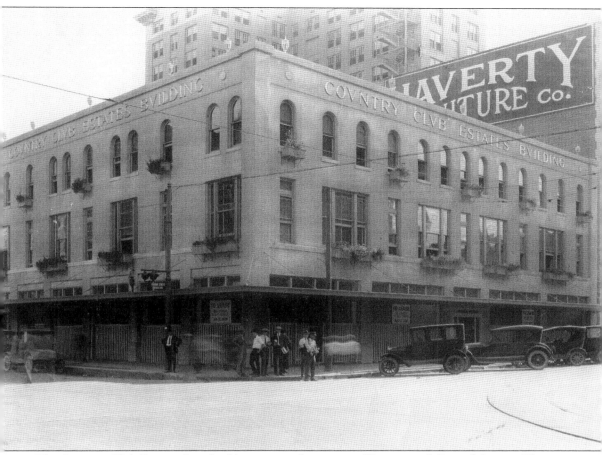

The Country Club Estates, Inc., building was at the corner of Fannin and Capitol Streets. The company's offices were on the second floor. Shortly after this photograph was taken, an addition was built on the roof that was in keeping with the large aspirations of the company and its vision of River Oaks. On the roof of the building and running diagonally across the corner was one of the largest and most unique electric signs ever erected in Houston. It was modeled after the shield or logo adopted by Country Club Estates and is 35 feet long, 24 feet high, and illuminated by 350 electric lights. The Hogg brothers and Hugh Potter knew the importance of branding long before it was taught as a marketing concept. All details of promotion, even the size of their signage, were designed to imprint a great perception of the River Oaks development. (Courtesy of Joan Potter Cullinan Hazelhurst.)

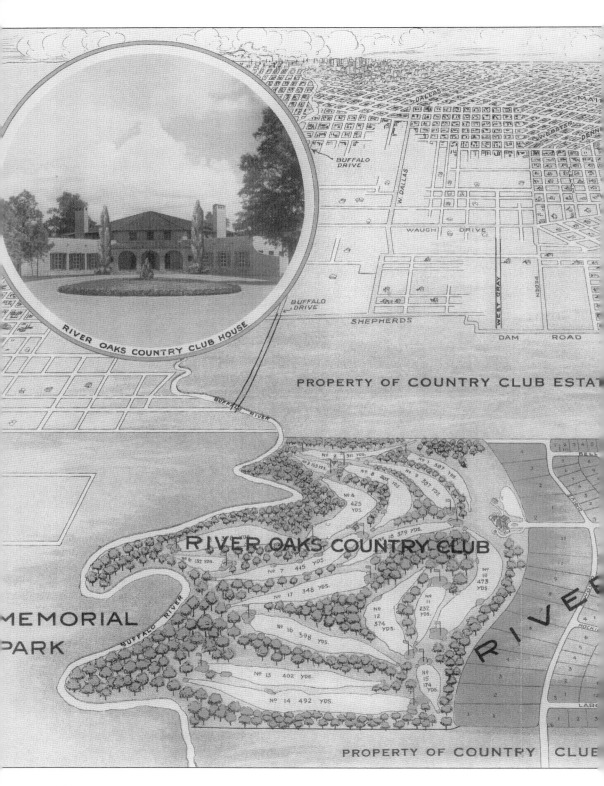

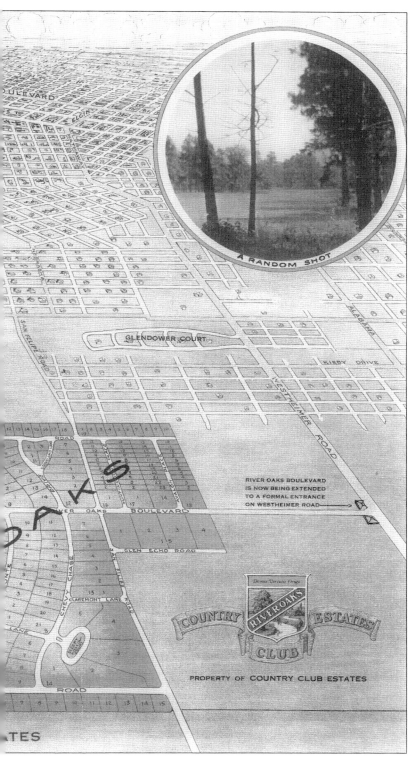

When the Country Club Estates project was several months old, considerable progress had been made in the layout shown in this map. William C. Hogg, Mike Hogg, and Hugh Potter bought what was known as the Hanna tract of 161 acres lying immediately east of the Country Club Estates land. Mike Hogg already owned 113 acres adjoining the Southern Pacific right of way between Buffalo Bayou and San Felipe Road. Their plan was to acquire control of something like 1,100 acres in one large tract. These men, nicknamed the "Hogg-Potter syndicate," bought out the stock of Country Club Estates Company under a trade with the individual members and the country club. While the details were worked out, another corporation was formed to buy adjoining acreage, the Widee Realty Company. (Courtesy of Joan Potter Cullinan Hazelhurst.)

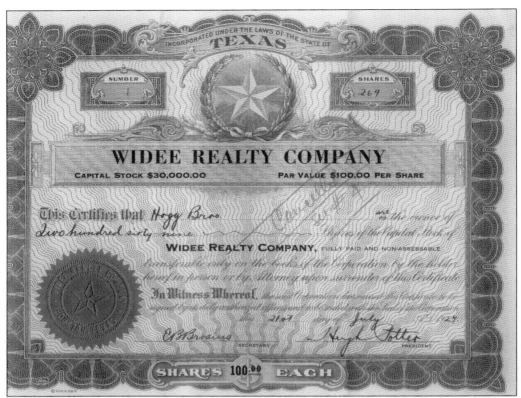

On March 15, 1924, Hugh Potter, L.P. Lollar, and David N. Picton Jr. officially filed papers to form a private corporation named the Widee Realty Company. The primary purpose of this venture was the purchase, sale, and subdivision of real property and the accumulation and loaning of money for that purpose. The corporation was formed for 50 years with a capital stock of $30,000 divided into 300 shares of $100 each. The purchases were made by a number of different persons who worked for Widee Realty Company, and the prices steadily increased. T.W. House, A.C. Guthrie, and Thomas Ball paid $500 an acre for the first 360 acres, but now the cost ranged from $1,000 up to $3,150 depending on the location and seller. The average price when all the land was purchased was $2,000 per acre. (Both, courtesy of Joan Potter Cullinan Hazelhurst.)

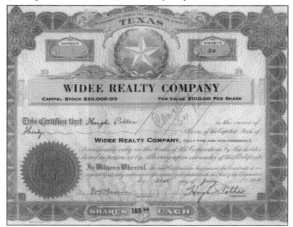

By 1924, the Hogg family was already legendary. Gov. James Stephen Hogg and his wife, Sallie Stinson Hogg, had four children: Mike, William, Thomas, and Ima. This portrait is of Mike Hogg. A Texas legislator, businessman, and civic leader, Hogg was born in Taylor, Texas, in 1885. He attended the University of Texas Law School in Austin, where his roommate was his lifelong friend Hugh Potter.

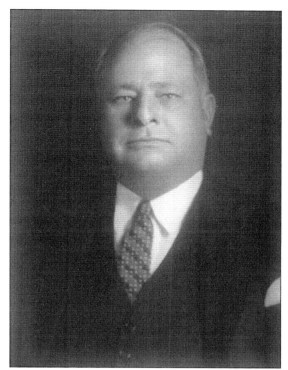

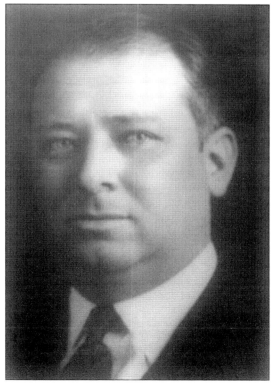

Will Hogg, a businessman and philanthropist, was born in Quitman, Texas, in 1875. He also attended the University of Texas Law School. Mike and Will incorporated as Hogg Brothers in 1921. During the 1920s, Hogg Brothers, Inc., was occupied with the business of investing in Houston real estate and civic projects. (Courtesy of Joan Potter Cullinan Hazelhurst.)

Hugh Potter told the *Houston Gargoyle*, "We were riding horseback one day on the old Hanna homestead, adjoining the original River Oaks Country Club property. The idea occurred to me, as I looked around at those lovely trees, that there might be some money in it, if one could get some of that land and cut it into home sites. I told Mike. He agreed with me enthusiastically. We pushed out with the thing, managed to get an option on two hundred acres. Then Will Hogg blew in on one of his periodic visits. We confided our plans in him. He began at once to look at a deal further than either of us had dared. 'Why stop at 200 acres?' he asked. 'Why not buy out the country club? Why not make this thing really big, something the city can be proud of?'" (Courtesy of Joan Potter Cullinan Hazelhurst.)

Huge Potter was born and raised in Gainesville, Texas. He attended the University of Texas (UT) for three years before transferring to Harvard, where he finished his bachelor of arts degree. His father suggested he come back to Texas, and he did, finishing with a law degree from UT. He was a renowned debater who never lost an intercollegiate debate during his college career, and this was a natural talent for success in civil law or, for that matter, real estate promotion. He began as a clerk in Gov. James Hogg's law firm with a salary of $75 a month, married his first wife, Florence Scott, in 1915, and had two sons, Hugh Jr. and Scott. (Courtesy of Joan Potter Cullinan Hazelhurst.)

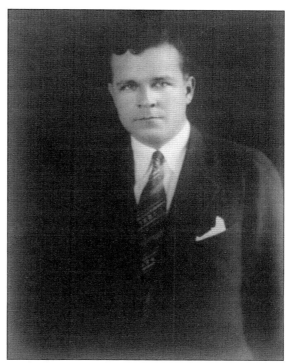

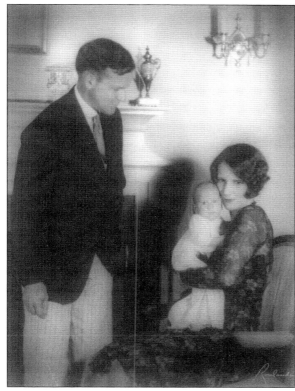

Potter's first wife died, and in 1927, he married Lucile (Tiel) Lister. The photograph at left is a picture of Lucile and their precious baby girl Joan. (Courtesy of Joan Potter Cullinan Hazelhurst.)

In 1923, Mike Hogg bought 118 acres south of Buffalo Bayou adjoining the River Oaks Country Club. He named it Tall Timbers for good reason. It was a densely wooded area, and game was plentiful. An hour's horseback ride from the center of town, and one found oneself in the middle of forest and farmland. Many of Hogg's close friends used the area as a weekend retreat. Pictured here are Lucile (Tiel) Potter, Raymond Dickson, Olga Wiess, Daisy Leach, Kate Neuhaus, Garland Howard, and Hugo Neuhaus. Lucile was the wife of Mike's classmate and best friend, Hugh Potter. (Courtesy of Joan Potter Cullinan Hazelhurst.)

Pictured from left to right, Hugh Potter, Irvin Cobb, and Mike Hogg enjoy a relaxing afternoon at the Varner Hogg plantation in West Columbia, Texas. In 1901, former governor James Stephen Hogg purchased this land, and after his death, large quantities of oil were found, making it possible for the Hogg family to leave a lasting positive effect on the city of Houston through their civic consciousness. The picture below was taken looking west on Kirby Drive from Shepherd Drive. Twenty-five men and three mules are preparing the road for surfacing. Although most of the roads leading into River Oaks in 1924 were not paved, inside of the River Oaks section, there were five miles of permanent paving and eight miles of sidewalks. (Both, courtesy of Joan Potter Cullinan Hazelhurst.)

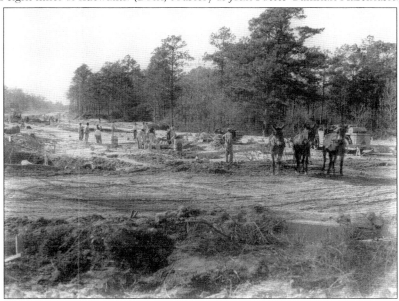

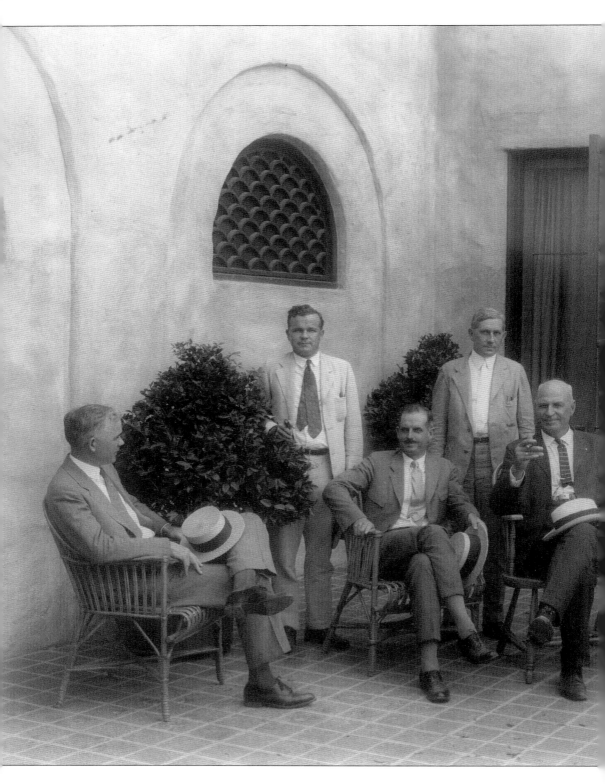

In 1924, Country Club Estates, Inc., held a reception at the River Oaks Country Club to introduce a new phase of the development. It had a $125,000 clubhouse, a golf course worth $60,000, drainage aqueducts worth $100,000, sanitary sewers worth $100,000, electrical lighting, and telephone wiring. It was time to hire the Kansas City firm of Hare and Hare, landscape architects, to take the plat by Herbert Kipp and expand the area in keeping with the park-like atmosphere. Pictured here is a reception given for Hare and Hare. From left to right are (first row) Mayor Oscar F. Holcombe, S. Herbert Hare, city planning commissioner H.A. Havelston, Mike Hogg, and city planning commissioner W.R. Britton; (second row) Hugh Potter, city planning commissioner J.H.B. House, and A.L. Anderson. (Courtesy of Joan Potter Cullinan Hazelhurst.)

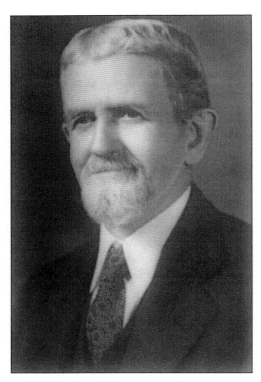

Pictured here are Sid Hare (left) and his son S. Herbert Hare (below). Hare and Hare worked with the Houston Parks and City Planning Departments, which resulted in plans for most of the city's parks, including Memorial Park and Hermann Park. They were hired by Country Club Estates, Inc., to take the plat laid out by Herbert Kipp, a drainage engineer, and improve or expand upon his plans. (Courtesy of Historical Society of Missouri Research Center–Kansas City.)

In a testament to Kipp's unique and brilliant planning, Hare and Hare adopted his layout and continued with the area, keeping with the park-like atmosphere. They also planned a landscaped parkway drive to run from Sam Houston Park along the south bank of Buffalo Bayou, cross the bayou, and terminate at Memorial Park. Herbert Hare was quoted as declaring "Houston will have a permanent residential district that for artistry, natural beauty and freedom from encroachment will have few equals in the country." (Courtesy of Historical Society of Missouri Research Center–Kansas City.)

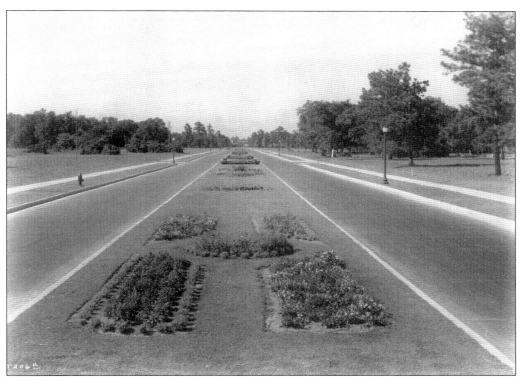

This photograph shows work beginning on the beautification of the esplanade leading to the River Oaks Country Club. In 1925, Hugh Potter sent out 54 special delivery letters to prospective buyers to announce the opening of an elite 92-acre "residential retreat" bordering the River Oaks golf course. Known as Homewoods, this area had larger parcels of land on which to build. Below is a stock certificate issuing Country Club Estates 80 shares of stock on February 25, 1925, with Hugh Potter as the president. The Hogg-Potter syndicate continued to build up to the 1,100 acres because it was, as Potter described in a letter, "heavily wooded, it would be a high class residential district on a waterway (Buffalo Bayou) and the eastern portion of the property lies less than three miles (as the crow flies) from the center of town." (Both, courtesy of Joan Potter Cullinan Hazelhurst.)

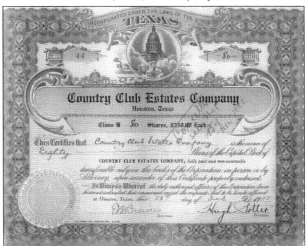

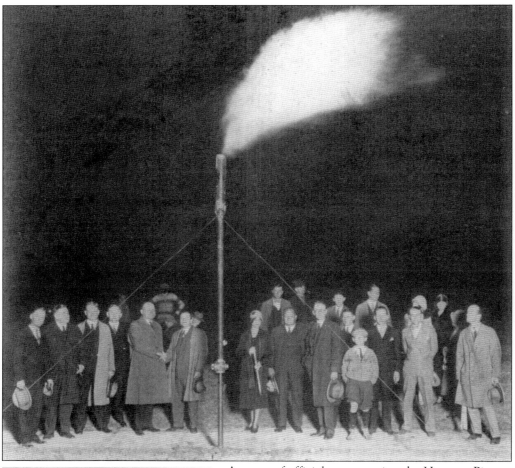

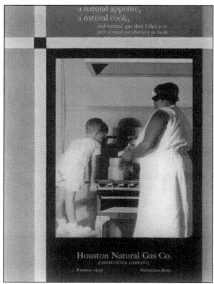

A group of officials representing the Houston Pipe Line Company, Houston Natural Gas Company, and Country Club Estates gathered on River Oaks Boulevard on March 3, 1926, to witness the completion of the River Oaks system of natural gas. This 12-foot flame is fueled by gas lines coming from a well 177 miles away. Included in the picture above are Calvert C. Tucker, chief engineer; George A. Hill, director; C.B. McKinney, manager; Capt. E.H. Buckner, president of the Houston Pipe Line Company and Houston Natural Gas; Hugh Potter, president; Mike Hogg, vice president; and Frank Sheffield, sales representative. After this picture was taken, the River Oaks Corporation advertised that natural gas was being piped to every home site and that this was the first domestic use of the fuel in the city. At left is an advertisement that appeared in the *River Oaks Magazine*. (Above, courtesy of Joan Potter Cullinan Hazelhurst; left, courtesy of Woodson Research Center, Fondren Library, Rice University.)

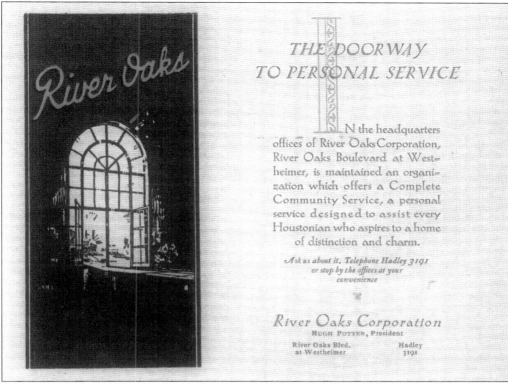

Founders of the River Oaks Corporation developed a cohesive, directed-marketing campaign that centered on a "Complete Community Service" as touted in the postcard promotional mailer in the above photograph. Interested buyers could call or simply drop in and sit across the desk from Hugh Potter (bottom). He was determined to give "a personal service designed to assist every Houstonian to a home of distinction or charm." This service would include a tour of the speculative homes funded by the Hogg brothers to attract buyers. The office was completed on October 27, 1927, and demolished in 1951 to make room for the building of Episcopal Church of St. John the Divine. (Both, courtesy of Joan Potter Cullinan Hazelhurst.)

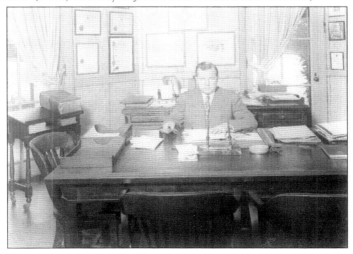

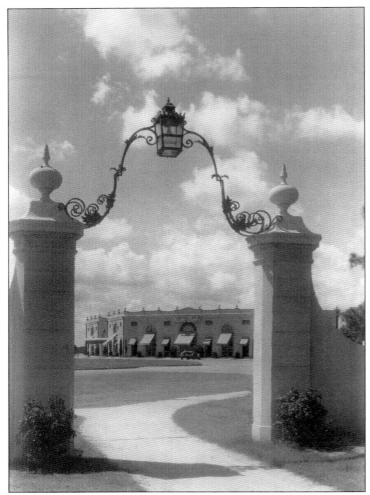

The beautiful Georgian gateway (left) leading into the River Oaks offices was purposefully elegant and finely crafted. Designed by John Staub, these gates gave an indication of the type of residences that were to follow with ornamental iron work by Weber Iron and Wire Company. The River Oaks Corporation had to create the illusion of a completed subdivision in order to sell the lots. This area was considered "out in the country" to most Houstonians. In order to sell the lots, 12 houses were built from 1924 to 1929 as examples of the tone of the subdivision. (Both, courtesy of Joan Potter Cullinan Hazelhurst.)

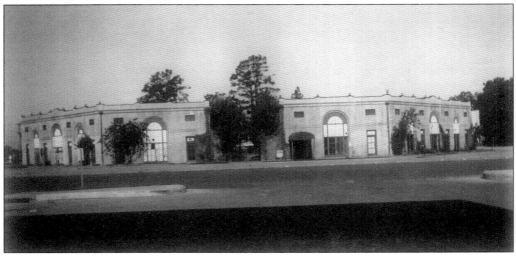

The standard design in River Oaks was a central street lined with house sites. Most of the east-west streets are gently curved to improve the landscape views. The land is flat, except in a few instances—the intersection of Pine Valley and Troon Road and Troon Falls and River Oaks Rock Garden on Troon Road. The picture above shows the beginning of Sleepy Hollow Court, and the image below shows Troon Road, which dipped so low on the west that an automobile could not enter. This rock garden was intentionally left as open space for a local park. (Both, courtesy of Joan Potter Cullinan Hazelhurst.)

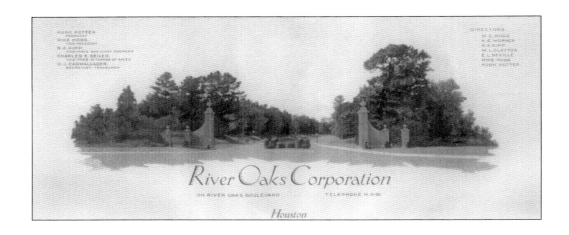

The River Oaks Corporation knew the benefit of presenting a clear message to prospective clients. It used the beautiful Georgian gates and lush, flower-filled esplanade in its collateral pieces as well as billboards around Houston. In 1945, Hugh Potter said in an interview, "There I was, a lawyer, engaged in a project for which you needed engineers, architects, landscape architects, advertising men, and salesmen. I was none of them. Yet it was up to me to employ the best men I could find in each field and coordinate them. You might say (he clapped a half smoked cigar into his mouth), I started coordinating them." Potter spent the first year traveling around the country getting the advice of community builders such as J.C. Nichols of Kansas City. (Both, courtesy of Joan Potter Cullinan Hazelhurst.)

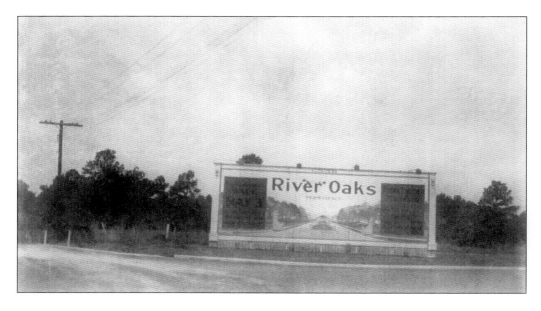

The River Oaks subdivision was classified by the River Oaks Corporation as a "site both public and private, with occupied and restricted private residences." Some of the first residents were golf enthusiasts, as seen above, who joined the country club and then bought lots nearby to build their homes. The first homes were constructed to be used as private summer homes or by the River Oaks Corporation as speculative showcases. The River Oaks subdivision was planned to offer home sites for a variety of income levels. Genteel dining, alfresco, was and is still experienced by club members (right). In a 1927 brochure, the River Oaks Corporation used the advertising slogan "a distinguished experiment in fine living." (Both, courtesy of Joan Potter Cullinan Hazelhurst)

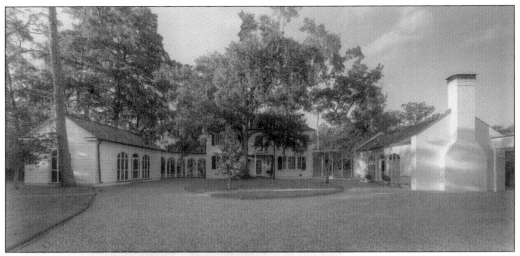

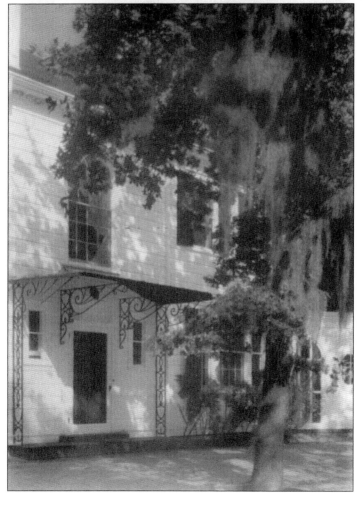

The William Lockhart Clayton home was the first to be built in River Oaks in 1924 and was designed by Houston architect Birdsall P. Briscoe. It was built as a summer house for the Clayton family. Clayton was cofounder of the Anderson-Clayton Cotton Company, which grew to become one of the world's largest cotton brokerage firms. The two-story house was designed in the Colonial Revival style, and it faces the River Oaks Country Club Golf Course. These photographs were taken in the 1920s. Descendants of the Clayton family have continuously occupied the premises. The current resident, Susan Clayton Garwood, remarked, "It is a privilege to be able to continue family ownership of this special spot for five (including my children) generations." (Above, courtesy of Jim Olive Photography; left, courtesy of Steve Griffin.)

In a 1929 passport photograph for a trip to Buenos Aires, Will Clayton is pictured with, from left to right, Sue Clayton, Sue's niece Sue Vaughan, and his daughter Julia Clayton. In a 1937 interview, Clayton said: "Latin America is taking more cotton." Clayton's firm established cotton-buying offices in Latin America and Africa in order to supply its foreign sales agencies with cotton at competitive rates. While Clayton was expanding his business abroad, he fought the farm policies of the New Deal. One of Clayton's four daughters, Susan, married Maurice McAshan, and in the late 1930s, the Inwood home became their permanent residence. Their yard had a pool and a tennis court, and the McAshans held private tennis tournaments like the one below. (Both, courtesy of Susan Clayton Garwood.)

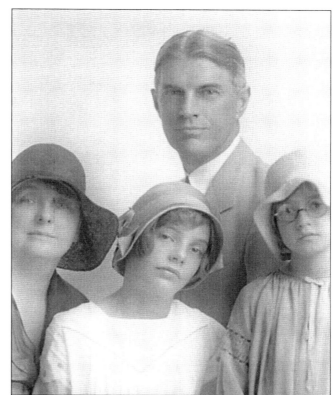

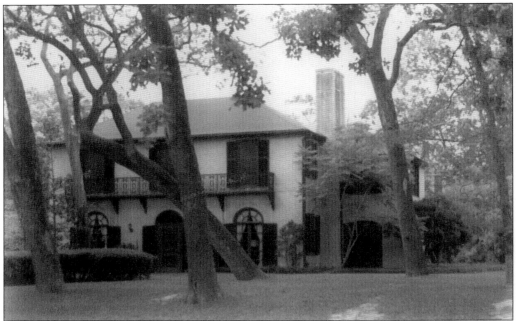

One of the first homes built by River Oaks Corporation as a speculative house was erected near the country club on 3374 Chevy Chase Drive. Designed by John F. Staub, it was a compact and small-scale home described as Latin Colonial with pink stucco and blue-green shutters. Staub was one of three architects hired by Country Club Estates to design model homes to attract potential buyers. In 1926, this home was purchased by David Means Picton Jr. (pictured below). The Picton home was designed to accommodate the Houston climate, and the major living areas and bedrooms faced southeast to capture the gulf breeze. John F. Staub's architectural style was very well regarded by Houstonians. Today, many Staub homes are listed in the National Register of Historic Places. (Both, courtesy of Alice Picton Craig.)

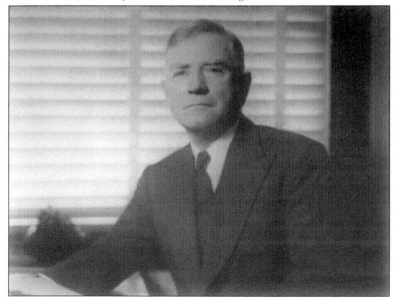

David Picton Jr. attended both Harvard and the University of Texas Law School, where he was a classmate of Mike Hogg. He took additional courses in maritime law at Harvard Law School and then worked as a lawyer for Hogg Brothers and Country Club Estates. In 1926, when the Picton family bought their home in River Oaks, it was considered out in the farm country and much farther from the heart of downtown than their home on Mount Vernon Street. Daughter Alice Picton Craig commented, "When we were young girls, we moved to Chevy Chase in River Oaks, and there were only a few houses. South of San Felipe was woods and South of Westheimer was prairie. I can remember Phoenix dairy delivering milk in a horse-drawn wagon." In the summer of 1928, while the girls were away on vacation, Will Hogg asked staff architect Charles Oliver to design the girls a playhouse. This was a gift from Hogg to the Picton girls, and it was built close to their parents' residence. (Both, courtesy of Alice Picton Craig.)

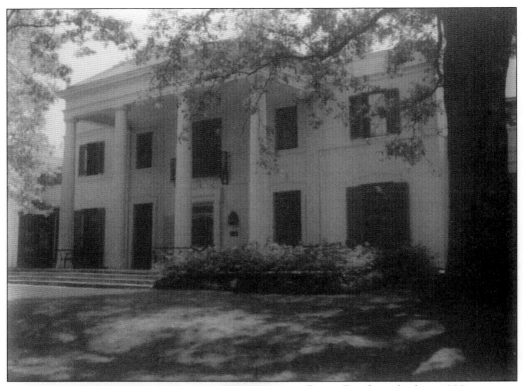

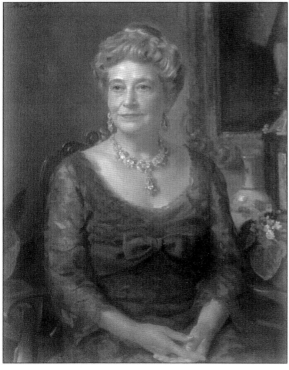

Bayou Bend was built in 1928 at a cost of $217,000. It was a joint project of two highly regarded architects, John F. Staub and Birdsall P. Briscoe in the Homewoods section of River Oaks. The house was designed for Will, Mike, and Ima Hogg for each to have separate living areas. Miss Hogg was active in the design of this residence and accompanied Staub and Briscoe to New Orleans to buy ironwork for the front balcony. Described as "Latin Colonial", the exterior is pleasing light-pink stucco with green louvered blinds and a copper roof. She lived at Bayou Bend into the 1960s although she gave the property to the Museum of Fine Arts in Houston in 1957. Joan Blaffer Johnson visited Miss Hogg in the 1960s at her last home, the Inwood Manor on San Felipe, and was intrigued by her furnishings. (Both, courtesy of Jim Fisher, Harris County Historical Commission files.)

Bayou Bend has formal gardens. Clio, Diana, and Euturpe Gardens are named for muses and goddesses. The other gardens are named White, East, Butterfly, and Carla. Ima Hogg decided to create winding, whimsical gardens that served as outdoor living areas. She hired the celebrated Ruth London to design the East Garden as an outdoor room that extended the east facade of the house into the landscape. London designed many early River Oaks gardens, including the one at the Mellinger-Harris home. Ellen Biddle Shipman, a nationally recognized landscape architect, is credited as having designed the Diana Garden. (Courtesy of Steve Griffin.)

In 1961, the River Oaks Garden Club took over supervision of the gardens, which are now the only public gardens in Texas that practice organic gardening. (Courtesy of Steve Griffin.)

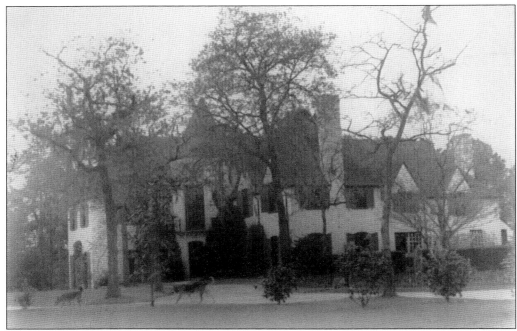

Mike and Alice Hogg bought Frederick Proctor's home next to Bayou Bend. This home was designed by Staub and Briscoe in 1928 in a Norman manorial style with a circular entrance tower, and it shared a driveway with Bayou Bend. Judge Proctor's seven-acre tract had frontage on the golf course of the River Oaks Country Club and Buffalo Bayou. One theory is that the Hoggs called the house Dogwoods after the popular humorist O.O. McIntyre suggested the name because of the number of hunting dogs Mike Hogg kept. But it may have simply been the dogwood trees on the property. Birdsall P. Briscoe built a two-story garage and servants' building with its own tower, a condensed replica of the main house. The beautiful Clock Garden was a favorite destination on the annual Spring Flower Garden Pilgrimage called the Azalea Trail. The first one was held in 1936 with 3,000 people from 20 states in attendance. (Both, courtesy of Steve Griffin.)

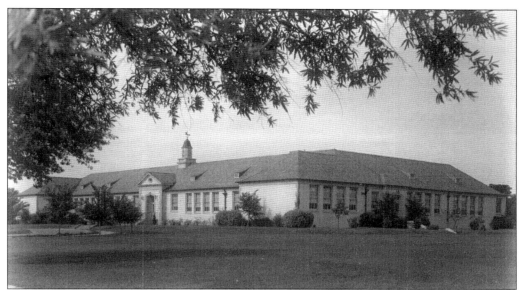

In 1929, River Oaks Elementary School opened its doors. It was one of six schools designed by architect Harry Payne for the newly formed Houston School District. The curriculum was designed by John Dewey of Columbia University. William M. Anderson spearheaded the landscaping plan. Margaret Eva Davis (right) was the first principal. Previous to coming to River Oaks School, she had taught at a small private elementary school in Scarborough-on-the-Hudson, New York. She was an extremely forward-thinking educator. The kindergarten was outfitted with an unusual piece of equipment: an indoor jungle gym. The school also boasted a science lab where students could observe real animals and conduct nature studies. (Both, courtesy of Joan Potter Cullinan Hazelhurst.)

The area where River Oaks was platted was considered farmland and not residential. The subdivision had been planned to be affordable to every income level. In 1925, the property was selling for as low as 25¢ per square foot to as much as 75¢ or higher, but the bulk of it sold for 40¢ per square foot. Hugh Potter wrote in a letter to his sales force, "You can without question, feel that you are selling this property at such a price as to make it an excellent investment for anybody." Advertising genius Don Q. Riddle was hired to mount a campaign to attract investors of all income levels. He had the gift of using imagery with few words to convey a message. This advertisement from the *Houston Gargoyle* brought the River Oaks Corporation into the 1930s. (Courtesy of Jim Fisher.)

Two

1930s
ANYONE CAN AFFORD TO LIVE HERE

Buying property in River Oaks and moving one's family out to the country was slow to catch on until the 1930s. The Hogg-Potter syndicate (as Hugh Potter referred to their venture) conducted strategic promotions to attract buyers at all income levels. By the mid-1930s, homes were under construction and yards were landscaped to follow the house design. Trees were an integral part of the beauty of the lots, and if possible, early homes were built around the natural landscape. By 1937, the River Oaks Corporation had built the community center on Locke Lane and Lamar High School had opened to students, in part to relieve the overcrowding of San Jacinto High School. The building was designed by Lamar Cato, Louis Glover, and Harry Payne (who designed River Oaks Elementary).

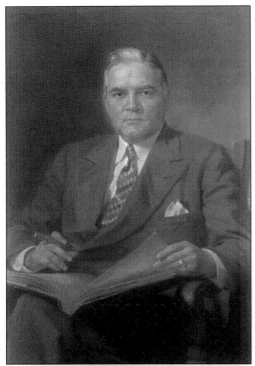

Oilman George Hill was the grandson of James Monroe Hill, who fought at the Battle of San Jacinto. Hill was the founder and first president of the San Jacinto Museum of History. John F. Staub designed the Hills' home in 1931 two lots at 1604 Kirby Drive. George Hill's son Raymond remembers, "I was five years old when Daddy bought our house. San Felipe Road was a high back shell road with ditches on either side all the way from River Oaks west to where Cinco Ranch is today. There was much more vacant land than homes. I'd ride my horse on San Felipe, which was a dirt road, all the way to where the Adickes dam is now. If you wanted to have a wonderful Huck Finn–type childhood, your parents had no reluctance to let you roam at will. We'd ride into the area that is now Tanglewood and hunt rabbits, build huts and lay traps." (Left, courtesy of Verlinde Hill Doubleday; below, courtesy of Steve Griffin.)

This is the Hills' lovely garden, designed by landscape architect Ruth London. Mary Hill was president of the Garden Club of Houston, and the Hills' was one of the gardens on a special tour for the Garden Club of America Annual Meeting held in 1939 in Houston. This was the first time the Garden Club of America held an annual meeting west of the Mississippi. The group also hosted a luncheon at the San Jacinto Museum at the Battlegrounds, which was of special interest to the Hills, as they gave their collection of Latin American art to the museum. Robert Joy was commissioned to paint George Jr. and Raymond, and this painting still hangs in the home of Jerauld (Jerry) and Raymond Hill. (Above, courtesy of Steve Griffin; right, courtesy of Verlinde Hill Doubleday.)

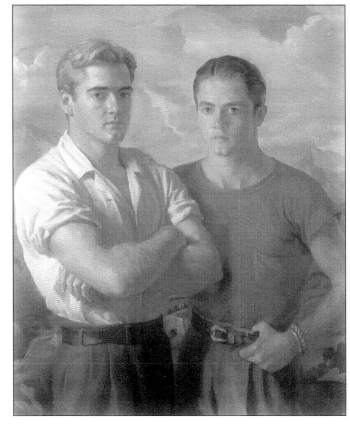

Among the fine services which River Oaks is dedicated to rendering, none is more important than the furnishing of homes and homesites for Houston's brides and grooms.

The beauty of River Oaks is ideal for enduring honeymoons. Its many advantages inspire a pride of possession which lifts the spirit of partnership.

In its wholesome surroundings any bride and groom may well indeed "live happily ever after."

River Oaks Corporation hired Don Q. Riddle, who knew the benefit of direct mail campaigns. This is the last page of a small brochure sent to prospective buyers. It begins: "Our grandfathers and mothers tell us of days when greater importance was attached to the possession of a home . . . the cottage of their youth . . . with candles shining through the windows at Christmas time . . . windows that also reflected the glow and glimmer of a lusty fire, inviting good friends to stop by and joke and smoke and be themselves convivially. But within recent years young people have begun to dream again of a bit of ground and a house with four walls and thoughtful parents, have begun presenting the dower of a house and lot." Some homes in River Oaks have been bequeathed from one generation to the next. (Courtesy of Joan Potter Cullinan Hazelhurst.)

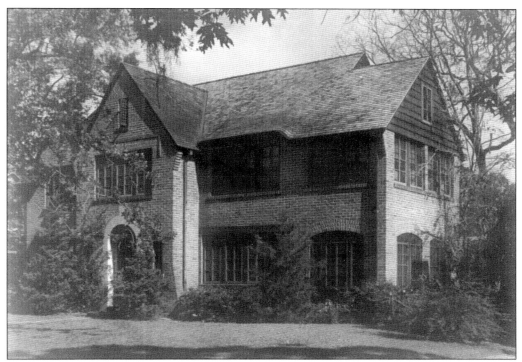

The house at 2510 Inwood Drive was a wedding present to Robert and Frances Stuart. She lived there from 1930 until her death in 1997. Her fondness for English cottage architecture began in 1926 on a trip to Europe. When the house, constructed for sale by well-known builder Russell Brown, became available, they chose it for their residence. It cost $25,000. (Courtesy of Woodson Research Center, Fondren Library, Rice University.)

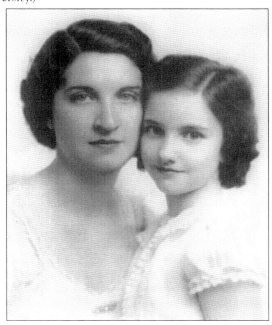

In May 1940, this picture of Frances Wells Stuart and her daughter was in the Mother's Day issue of *River Oaks Magazine*. Francita, her parents' only child, attended River Oaks School from 1936 to 1942. The carpool consisted of Pauline Arnold, Lee Tuttle, and Evans Attwell. All could have walked the few blocks to school, as there was very little traffic on Kirby Drive then. (Courtesy of Woodson Research Center, Fondren Library, Rice University.)

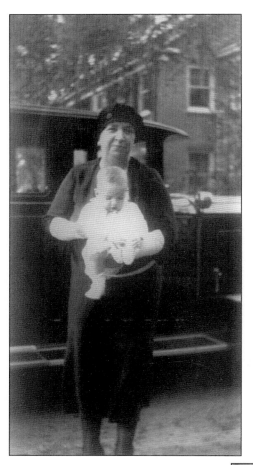

In this 1931 picture, Frances (later known as "Francita") returned with her grandmother Mrs. Thomas Walter Williams from Christ Church, where she was baptized by the Right Reverend Clinton S. Quin. She was the fifth generation of her family to be baptized there. An excerpt from Bishop Quin's diary, which was published in the *Texas Churchman*, reads, "November 23—Christ Church—baptized Frances Stuart, the great granddaughter of Rosa Lum Allen." Rosa Allen and her grandson Robert C. Stuart had assisted Bishop Quin in the founding of Camp Allen, a ministry of the Episcopal Diocese of Texas that was named for her. (Courtesy of Woodson Research Center, Fondren Library, Rice University.)

The *River Oaks Magazine* of May 1937 reported, "Pauline Arnold and Francita Stuart . . . inseparable little companions have played together since babyhood . . . there's only one step from one lawn to the other." Pauline later married distinguished physician H. Irving Schweppe Jr.; Francita married lawyer James G. Ulmer, retired senior partner at Baker Botts, LLP. The two neighbors made their debut the same year in 1951 when Pauline was at Smith College and Francita at Wellesley. (Courtesy of Francita Stuart Ulmer.)

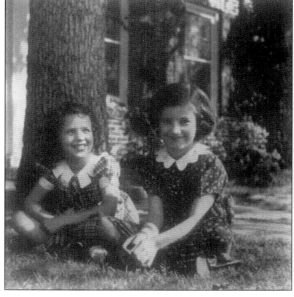

Francita is held by her grandmother Mrs. John Weems Wells while surrounded by older neighborhood children. In the background is the redbrick house of Henry and Pauline Arnold. It was designed by noted Houston architect Charles Oliver and built in 1929. Oliver was hired away from the Russell Brown Company in 1926 when he became the in-house architect for the River Oaks Corporation until 1931. Pauline was active in the River Oaks Garden Club, having served as one of its earliest presidents. Henry was the corporate secretary and treasurer of Humble Oil (now Exxon). (Courtesy of Pauline Arnold Schweppe.)

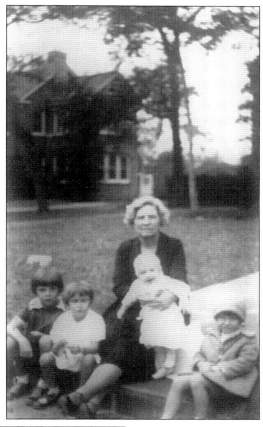

Friends are watching "Tony the Clown" on Francita's sixth birthday, May 20, 1937, at the farm of her grandmother Rosa Allen Williams on Old Galveston Road. Included in this photograph are neighbors Pauline Arnold, Marilyn "Dumplin" Miller, Betty Lou and Ann Langston, Adelaide Scott, Nancy Claire Turner, Anne Hogan, George Francisco, and George Heyer. (Courtesy of Francita Stuart Ulmer.)

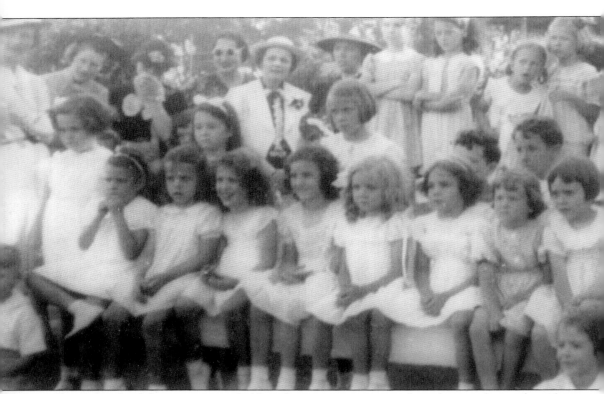
Even when birthday parties were held in the country, attire was formal: party dresses for girls, suits for boys, and hats for mothers. In addition to those mentioned elsewhere on the guest list for Francita's 1937 birthday party were Marguerite Andrews, Bonner and Jimmy Baker, Mary Wyche Means, Emmy Coates, Nancy Welsh, Barbara Ivy, Eliza Lovett, Marjorie Shepherd, Bobby Johnston, Sue Ledbetter, Helen and Marilyn Graves, Caroline Staub, Mary Bain Haralson, Tucker Blaine,

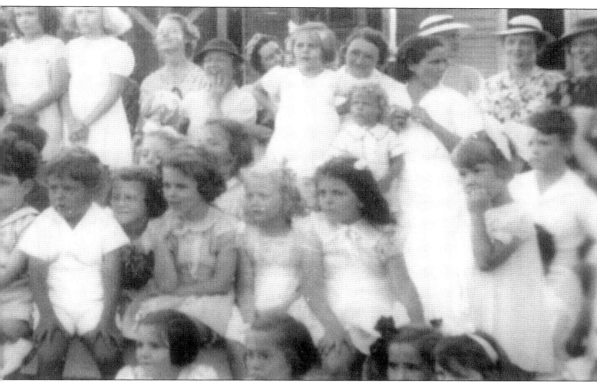

Marcia Moore, Khleber Attwell, Julia Picton, Rosemary Hamner, Anne Watts, Clare Williams, Andrea Simmons, Preston Moore, Ned Morris, Lucile Mellinger, Adelaide Scott, Anne Hogan, Bette Bettes, Chaille Cage, Thelma McFarlane, Jim Darby, Brenda Blalock, Alex and Dede Adams, Maconda Brown, Jane Lawhon, Alice and Jane York, Virginia Ann and Barbara Fitch, Eloise Frame, Louise Estill, George Allen, and Charlie Perlitz. (Courtesy of Family Friends.)

The farm had been in Francita's family for several generations. It was near the home of cousin Mary Josephine Milby and her husband, George Hamman—a large brick house with a spectacular entry through a lane of oak trees. The farm is now Cesar Chavez High School, and the Hamman property is an industrial storage facility. Birthday cakes then were elaborate works of art. Ice cream was in animal molds. Staff came from home to serve and nurses to help with the children. Seen at the cake table at the farm in 1935 are several children including Paul Pressler, Joan Wier, and Sarah Faulkner. (Courtesy of Francita Stuart Ulmer.)

This image, showing a typical 1930s birthday for Paul Pressler (in front center looking down), was taken in June 1936 at 3394 Chevy Chase Drive. The mothers were inside, while nurses (back left) wore white uniforms and supervised the children. (Courtesy of Judge Paul Pressler.)

Buying property in River Oaks was slow to catch on until the 1930s, when families began to move in and River Oaks Corporation developed more of the 1,100 acres. By the mid-1930s, the houses were being built and the yards landscaped; many residents hired professionals like Ruth London. Trees were an integral part of the beauty of the lots, and if possible, early homes were built around the natural landscape. The picture below shows an Easter egg hunt in the spring of 1939 at the E.E. Townes home at 3394 Chevy Chase Drive for the six grandchildren. From left to right are Mary Louise Townes (lived on Reba Drive) Aileen Townes (Banks Street), Paul Pressler (Pine Valley Drive), Goss Townes (Reba Drive), Townes Pressler (Pine Valley Drive), and Charles Townes (Banks Street). (Right, courtesy of Steve Griffin; below, courtesy of Judge Paul Pressler.)

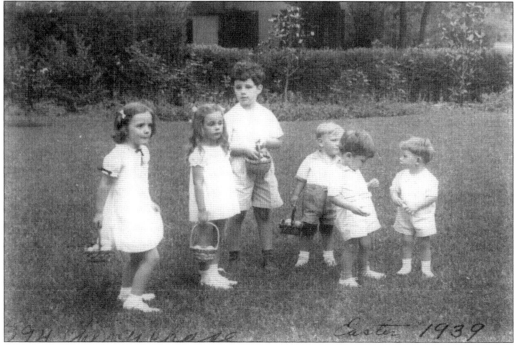

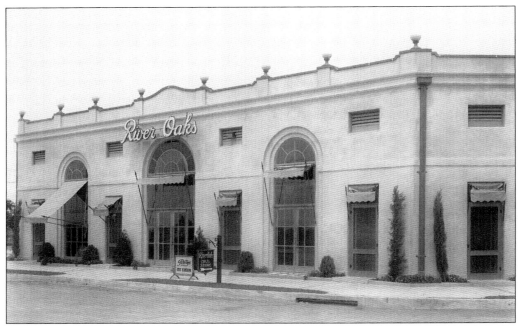

The River Oaks Drug Store was located where St. John the Divine Episcopal Church is now, on the corner of River Oaks Boulevard and Westheimer. According to old-time River Oaks residents, the drugstore carried everything necessary except for fresh produce. There was a soda fountain where children would gather after school to have a little social time before walking home to a waiting dinner. In the early days, children could wander the area at will without worrying their parents. It was a very safe neighborhood. The River Oaks Corporation had its own magazine in which local businesses could take out advertisements. The one below was used for several years to attract customers. (Above, image copyright Story Sloane's Gallery; below, courtesy of Steve Griffin.)

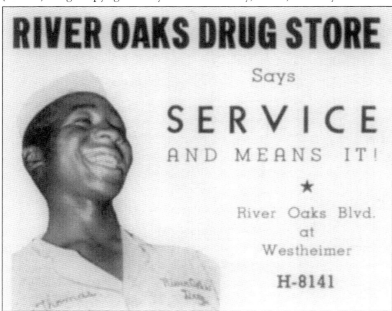

John Sweeney and Marguerite Mellinger bought a lot in Country Club Estates a few blocks from the golf course for $2,800. In 1931, they bought a second lot adjacent and paid double the earlier price. Architect John F. Staub was hired to design this American-style home on Del Monte Drive. Landscape architect Ruth London brought beauty to this elegant New England–type dwelling with rose gardens, banks of azaleas, and borders of bridal wreath. (Courtesy of Lucile Harris; below.)

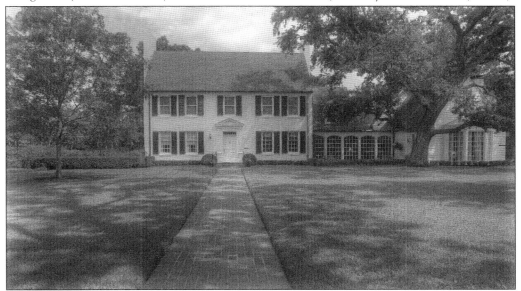

This is a photograph of the Mellinger house as it appears today. A tasteful, long, glassed-in front porch was added by Lucile Mellinger Harris, and John F. Staub was a consultant on this project. Lucile and her husband, Brantley Harris, have taken great care to preserve the overall intent and beauty of the Staub house. (Courtesy of Jim Olive Photography.)

John Sweeney Mellinger's occupation was listed as manager of the Sweeney Estate, a family enterprise dating back to the late 19th century in Houston. Mellinger was the official River Oaks air raid warden. Lucile remembers that the air raid equipment was kept handily in the front closet closest to the door. This picture of Mellinger was taken in 1923. The Mellingers' only child, Lucile, is on the front lawn with Spiffy, her mother's yellow-and-white tabby cat. Her father snapped this photograph of his very happy child one sunny afternoon, catching the subject unaware of the portrait. At this time, even leisure activities required appropriate and, in this case, darling play outfits. Lucile has fond memories of her childhood home being filled with the laughter from neighborhood children and of her chauffeur known only as Mr. Fullilove. (Both, courtesy of Lucile Harris.)

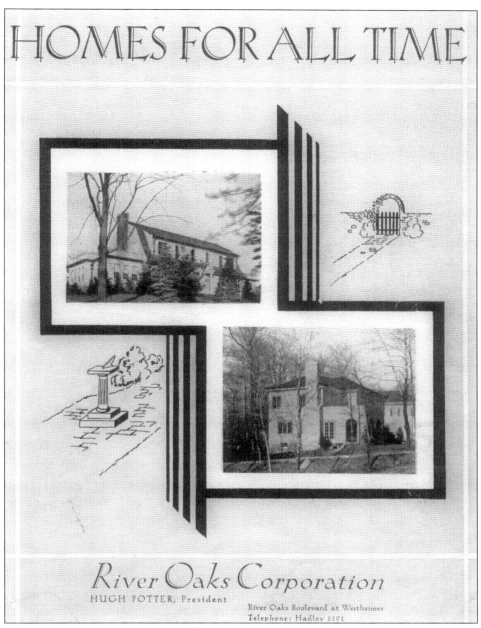

In 1932, the River Oaks Corporation published a 14-page advertising brochure where the Mellinger house was featured as the ideal John F. Staub–designed residence. The first paragraph inside the book had the title "Home Beauty Is In The Absence of Ugliness." The text used the word "ugly" four more times and ended "With costs down, with capable craftsmen available, dinginess, darkness and unnecessary ugliness can be replaced with charm, beauty and personality at a cost within the limits of the average income." The intent of the early developers was for anyone to be able to afford a home in River Oaks, and the sections were planned to accommodate all income levels. (Courtesy of Lucile Harris.)

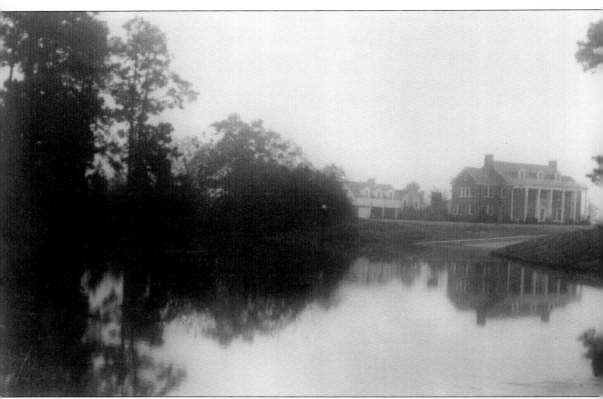

In River Oaks, the Hines Baker house is viewed from the intersection of Pine Valley Drive and Troon Road during the flood of 1935. Hines Holt Baker spent his entire career at Humble Oil, first in the legal department, then on the board of directors and as president and chief executive officer. His daughter Louise's friends from River Oaks School loved rolling down the hill at her house (a rare opportunity in flat Houston). In this picture, the water is so high that the property appears to have a lakeside lot. For three days, a storm lingered over Houston. The bayous were 52 feet above normal. In 1925, Hugh Potter explained, "This tract of land shown by the US topographical survey is from 60 to 65 feet above sea level, which is from 10 to 15 feet higher than any other high class residential district in Houston, a fact that in this flat section of the Country is most important." (Courtesy of Francita Stuart Ulmer.)

George Strake Sr. bought this home at 3214 Inwood Drive in 1935. In this aerial photograph, three small figures can be seen at the bottom left corner. These were Strake family members looking to see the plane circling the new construction. George Strake was the youngest of 11 children and a devoted member of the Roman Catholic Church. His son George Jr. recalls, "Dads first job at 11 years old was as a Western Union runner and he would put two dollars in the Sunday collection. He believed in giving back." Strake was cited one year as the most generous contributor to the Houston-Harris County United Fund charities, and Strake Jesuit College Preparatory School was named for him. (Courtesy of George Strake Jr.)

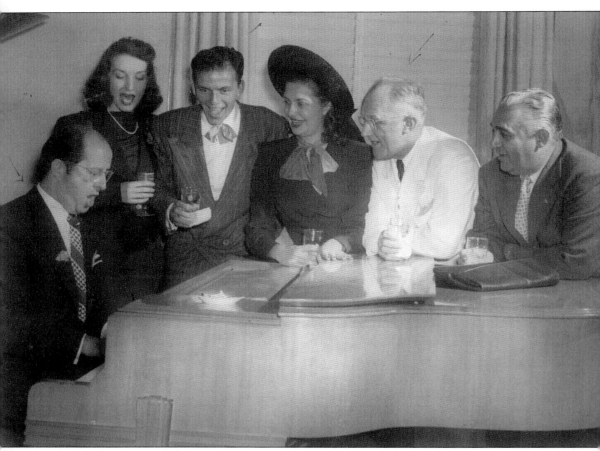

George Strake traveled the world enjoying the company of a variety of people. In this picture, comedian Phil Silvers plays piano while (from left to right) Dorothy Lamour and Frank Sinatra sing along. Strake is in the white suit between two unidentified revelers. Strake loved to sing. This photograph was taken at the Ramada Club, a Houston hot spot. Strake could communicate as easily with an oil field worker as with President Eisenhower and on many occasions did with both. His contribution to the oil industry was immense. After serving in World War I, he worked in the oil industry in Mexico and Cuba. Then he moved to Houston, where he noticed the topography of Conroe and felt sure that oil was beneath the surface. No one agreed with him, and he could not get outside financial backing. So, he used he own savings, drilled the well himself, and in 1931, he struck oil. Strake's discovery proved that Cockfield-Yegua sand was an oil-producing formation. This opened wildcatting in an area 50 miles wide and 500 miles long, from Texas into Louisiana and Mississippi. (Courtesy of George Strake, Jr.)

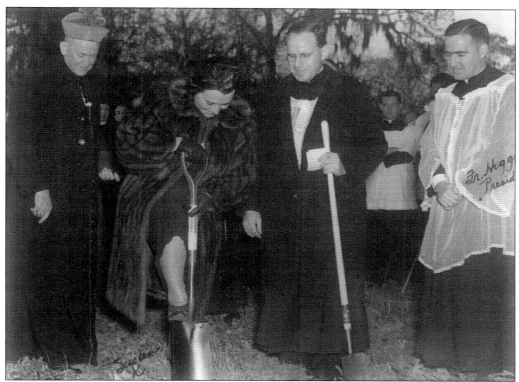

In this picture, Susan Kehoe Strake digs the first hole to begin construction of the new St. Thomas High School. The high school was relocated from its downtown location to a heavily wooded area considered by Houstonians to be "out in the country." This is where Shepherd and Memorial Drives meet today. At the time of this photograph, woods ran all the way down to Buffalo Bayou, and Memorial Drive had not yet been built. George Strake put down a large amount of seed money, which was quickly matched by other friends and donors. A devout Catholic, George was bestowed the honor of the Pontifical Order of St. Sylvester, which is the highest honor given by the Catholic church to a layperson. This order is one of five Orders of Knighthood awarded directly by the Pope as Supreme Pontiff. (Both, courtesy of George Strake Jr.)

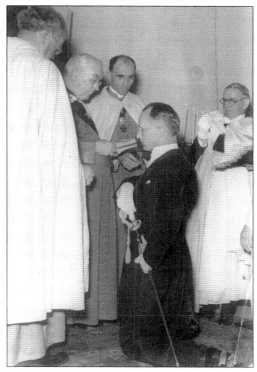

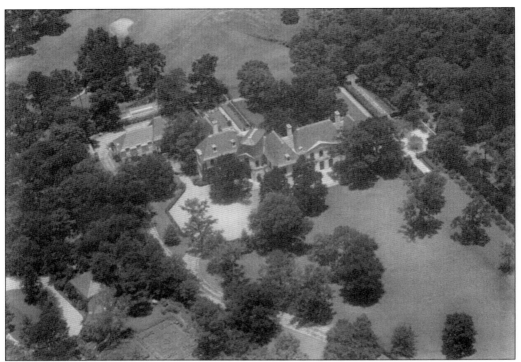

Regal in its dimensions, this gorgeous estate at 2960 Lazy Lane was the home of J. Robert Neal. According to Howard Barnstone, "Neal was a connoisseur of 18th-century French architecture and when he approached Staub he insisted on 'pure Louis Quinze.' Staub was floored—that was the last style he ever expected to do. A man of restrained tastes, he preferred to express himself in a less ostentatious fashion." A 1933 magazine article explained, "The Neal gardens were listed as one of the great gardens in the United States. The Olmsted Brothers of Massachusetts designed the gardens near the River Oaks Country Club." Alice Picton Craig remembered carrying eggs to Marian Neal, how pleased she was to receive them, and how daunting approaching the estate with a paper bag of eggs was to a young girl. (Both, courtesy of James Daniel Becker.)

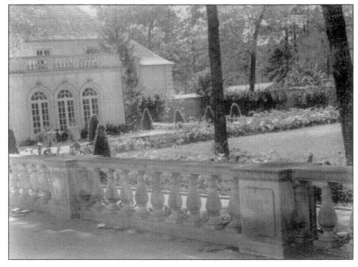

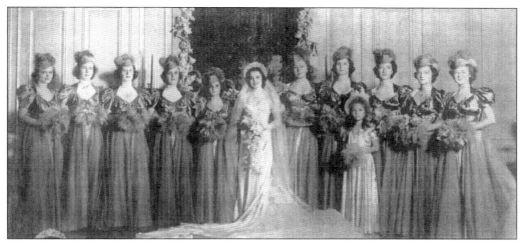

The Marian Neal and William Rubey wedding was as exquisite and opulent as the John Staub home and large estate where the Neal family lived. J. Robert Neal and Herschel Duncan were cousins, and both families made fortunes in the coffee business. Marian Neal's cousin Amelia Duncan is the third bridesmaid from the left. The photograph below was taken at Christmastime at the Duncan house located at 3320 Chevy Chase. Pictured are, from left to right, Harriet, Herschel "Mills" Jr., Katherine, Herschel, Linnie, and Amelia. Herschel founded the Duncan Coffee Company in 1917. In its humble beginnings, he roasted coffee beans at night and delivered them daily to stores in Houston. Later, son Mills worked as a sales executive and traveled the state, selling carloads of the company's Bright and Early brand to grocery stores. Herschel developed the Maryland Club blend, and for 46 years, until the brand was sold to Coca-Cola, Houston-based Duncan Coffee was famous nationally. (Both, courtesy of Sarah Rothermel Duncan.)

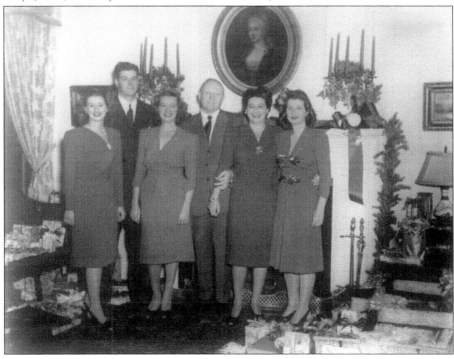

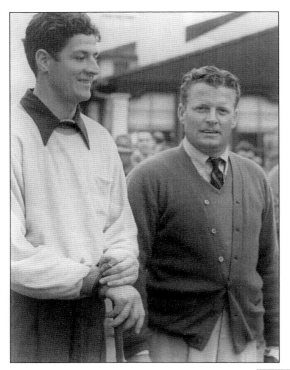

Mills Duncan (left) and golf legend Jimmy Thompson enjoyed the 1940 Western Open, held at the River Oaks Country Club. It was said that Thompson was to golf what Babe Ruth was to baseball. Thompson was quoted as telling Mills that he was the greatest long driver he had ever met. Duncan was introduced to golf at the age of four, and by adulthood, he could drive a ball more than 400 yards. He swung his first golf club at five.

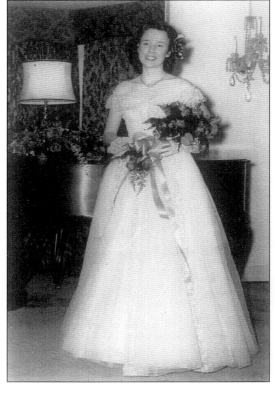

Mary Louis Rothermel, daughter of Louis F. and Mary Rothermel, lived in the home on Knollwood Drive that was designed and built by her uncle Bill. Mary Louis attended Lamar High School and is pictured in her senior year graduation dress. She was known to have a beautiful singing voice and would entertain family and friends with her creativity as a pianist and songwriter. (Courtesy of Sarah Rothermel Duncan.)

William G. "Bill" Rothermel Sr. was associated with George & Conway Broun, General Contractors, and with Olson Brothers in the 1920s. They built custom homes in River Oaks, North and South MacGregor, Rice, and West University Place. Bill designed the chapel and home of the Catholic Diocese of Galveston for Bishop Louis J. Reicher at Dickinson, Texas. Bill also designed and built the Rothermel summer cottage and pier on Galveston Bay near LaPorte. He joined his older brother Louis in 1931 as a partner in Maritime Oil Company, a refiner of high-octane gasoline, kerosene, oil, and crude oil products. Below, Bill designed and built the Louis F. Rothermel home, a Monterrey-style Colonial of stucco and exposed beams with tile roof and wrought-iron grillwork, at 3643 Knollwood Drive in 1941. (Both, courtesy of Sarah Rothermel Duncan.)

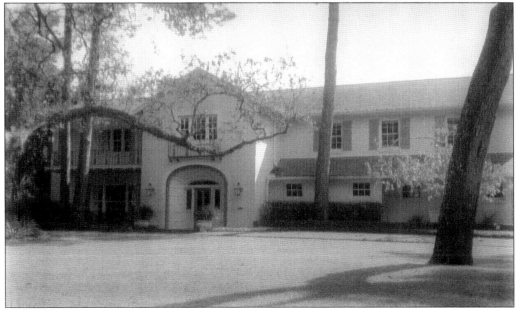

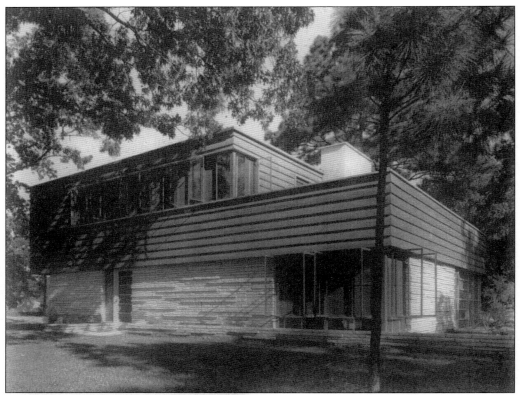

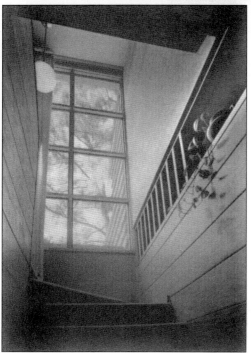

Architect Karl Frederick Kamrath built his own residence at 3448 Locke Lane in 1939. His unique design employed Texas limestone and rough-sawn Texas pine with a natural white stucco and brown gravel roof. Kamrath loved the idea of blending into the landscape. The interior continued with limestone, Texas pine, and natural plaster walls with a beamed ceiling. His floors were fully carpeted, and fireplaces were designed to burn cordwood. He continued this communion with nature and built a stair hall with a picture window that framed a huge bull pine tree. According to a feature article in the *River Oaks Times* magazine, "Kamrath wanted to build a livable home informal in character, with an eye for real economy, pleasing design, coolness, maintenance and adaptability to virgin landscape." (Both, courtesy of James Daniel Becker.)

Karl Kamrath and his wife, Jeannie, were avid tennis players. She was the first female tennis professional at both the River Oaks and Houston Country Clubs. She recalled the early years: "All the area was woods and there was only one home on Wickersham, owned by Mr. and Mrs. Vernon Elledge. We bought the land for $5,000.00. I remember the first house well, there was a pine tree visible through the stairwell and every time it stormed I worried about damage to the house. Luckily, it never did fall." Frank Lloyd Wright was Kamrath's mentor, and they visited frequently. Jeannie explained, "Wright was a brilliant and innovative architect. We knew him well enough to stay in two of his homes, but I don't think anyone really knew him." (Courtesy of Jeanie Kamrath Gonzales.)

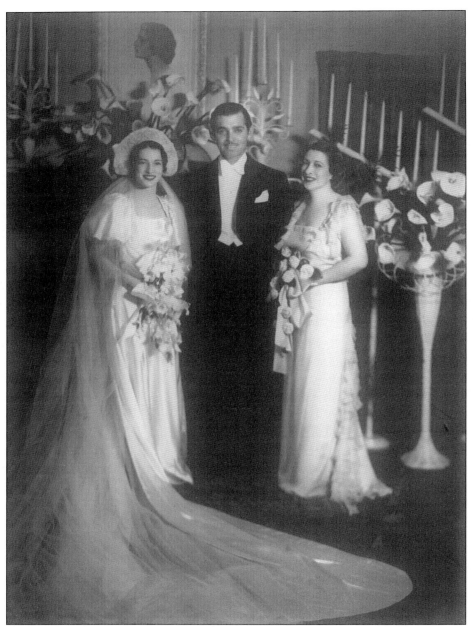

River Oaks residents had ties to Hollywood. After winning an Oscar for his role in *It Happened One Night* with Claudette Colbert, Clark Gable headed to Houston to escort his stepdaughter, GeorgeAnna Lucas (left), to the altar to marry Dr. Thomas W. Burke. Gable was married for nine years to stunning socialite Maria "Ria" Lucas Langham (right), whom he had met through her brother, Booth Franklin, in New York. The wedding had to take place to accommodate Gable's film schedule. GeorgeAnna and her mother, Ria, lived in Hollywood for several years, and she had a job as "ghost signer" for Gable's fan mail. As soon as the Burkes were married, the Gables left for Alaska, where he was to film *The Call of the Wild*. Gable's wedding gift to the young Burkes was land on which to build in River Oaks. (Courtesy of Maria Burke Butler.)

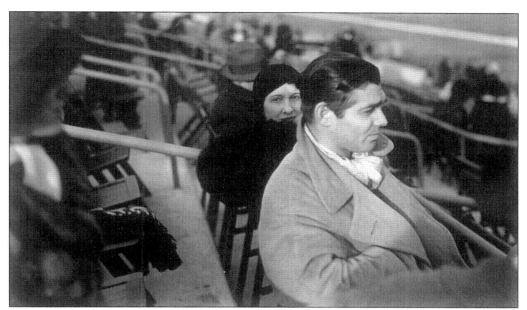

This photograph shows Clark Gable and wife Ria in 1937 at the Saratoga Race Track during a pause from filming. Maria Burke Butler describes, "Before there was television and modern day entertainment, the race track was a grand event for people from all walks of life." When GeorgeAnna and her son Tom went to Hollywood, Gable sent a limousine to pick them up and bring them to the set, where he picked up the child and introduced him to all present with a very wide smile. Gloria Swanson was a dear friend of Ria Gable and became a good friend of Alice Hogg Hansen. In a letter, Swanson wrote, "Ria dear: . . . please give my love to Alice, and tell her I had dinner with Jimmy Gardner the other night. He is such a darling boy." Below are the Gables with friends. (Both, courtesy of Maria Burke Butler.)

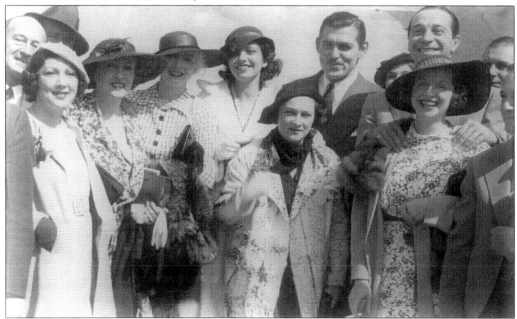

In 1939, the Saengerbund was a wonderful venue for weddings and celebrations. In this photograph, from left to right, Mrs. F.J. Iiams, Hugh Roy Cullen, Herve Burghard, and Mrs. Louis Duquette are seen dancing. Mrs. Iiams was married to a descendant of a member of the first Stephen F. Austin colony, and Hugh Roy Cullen was descended from an early East Texas family whose original family house he restored. (Courtesy of Lucile Harris.)

See you at the opening of our own

NEW River Oaks THEATRE

Watch for the date!
(SOMETIME THIS MONTH)

SEE OUTSTANDING MOVIES IN PERFECT COMFORT

The River Oaks Theatre, built in 1939, is located at 2009 West Gray Street. It was the last theater built in Texas by the Interstate Theatre Company and has an Art Deco design. Hugh Potter and Mayor Oscar Holcombe attended the opening night in November to see the David Niven and Ginger Rogers movie *Bachelor Mother*. (Courtesy of James Daniel Becker.)

Three
1940s
THE WAR YEARS

River Oaks was insulated somewhat from the austerity of the 1940s wartime economy, even though rationing of all types was observed by the residents. George and Hermann Brown built ships for the Navy that were frequently christened by daughters Nancy, Maconda, and Isabel, whose friends delighted in being asked to watch them break the champagne bottles. Men and women of service age enlisted in the varied armed services, and at home, the war effort was supported at every level, including school programs. In the November 11, 1945, issue of *This Week Magazine*, Dorothy Ducas wrote, "At the close of the war Hugh Potter was called to Washington to be the United State's first Construction Coordinator with the backing of President Truman and Reconversion Director John W. Snyder." Meanwhile, his development, River Oaks, was now the "Showplace of Houston."

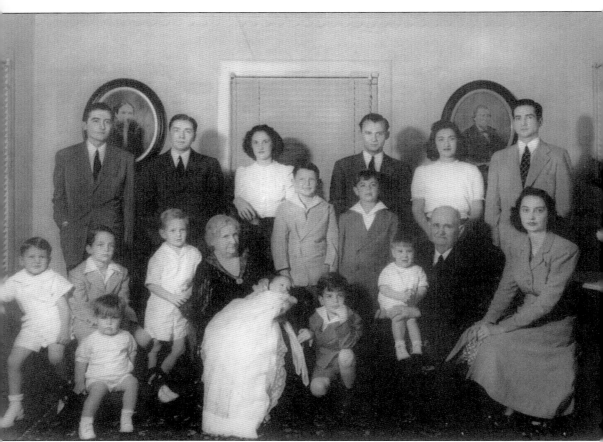

The Mother's Day 1940 issue of *River Oaks Magazine* featured Sam E. and Sallie Brashear McAshan with 15 of their 16 grandchildren and their first great-grandchild. Most of these families lived in River Oaks. From left to right are (first row) John Brashear McAshan, Khleber Van Zandt Attwell, Maurice McAshan Adams (the toddler in front of Khleber), Kirby Attwell, Sallie Brashear McAshan holding Sallie Ann Klep (her first great-grandchild), Norman DeGraaf Adams, William Franklin Kelly on lap of Sam E. McAshan, and Sarah Margaret McAshan Klep; (second row) Ernest James McAshan, Edward McAshan, Ella McAshan, Dr. Edmund McAshan Fountain, Mary Celeste McAshan, and Sam McAshan, Jr. The two boys standing in center are Allen McAshan Jr. (left) and Alexander Adams. (Courtesy of James Daniel Becker.)

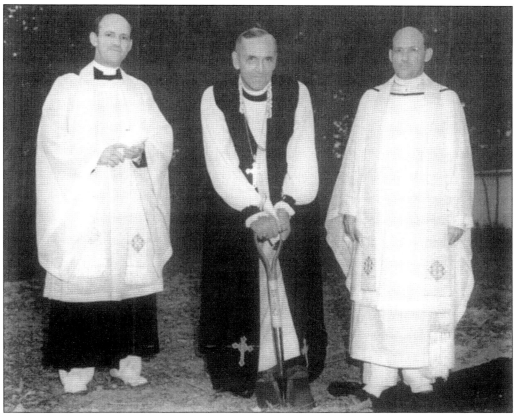

On August 12, 1940, the Right Reverend Clinton S. Quin removed the first shovelful of dirt for St. John the Divine, and the Reverend Charles Sumners and his twin brother, the Reverend Thomas Sumners (rector), were part of the lovely ceremony as well as Hugh Potter of the River Oaks Corporation. In a letter dated June 10, 1942, Reverend Sumners wrote to Hugh Potter: "I want to thank you, Hugh, for your understanding of my plan for the future of the Church in this community. It's just an extension of your own vision of a community of homes and schools. Your quick grasp of the potentialities of the future of the Church indicates your unselfish greatness. I know you realize something of my own difficulties in trying to present a vision even to alert minds." Parishioners supported the war effort, as shown below. (Both, courtesy of Joan Potter Cullinan Hazelhurst.)

This house was located at 3620 Meadow Lake Lane. This area now is referred to as the St. John's section of River Oaks or "section eight." In 1940, this was the home of Jessie Reese Smith, Edward C. Smith, Lydia Smith Brill, and James Edward Brill. The photograph below was taken of James Edward Brill in the backyard of his home playing with Rowdy (left) and Skippy, his faithful companions. This picture was taken from the porch of his home showing the dirt street behind him, which was San Felipe Road, and a house under construction on Olympia Drive. (Both, courtesy of James Brill.)

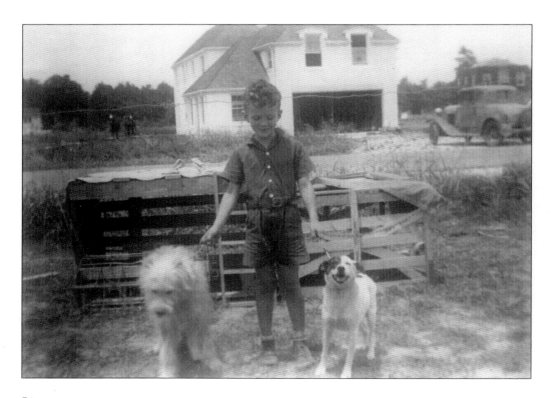

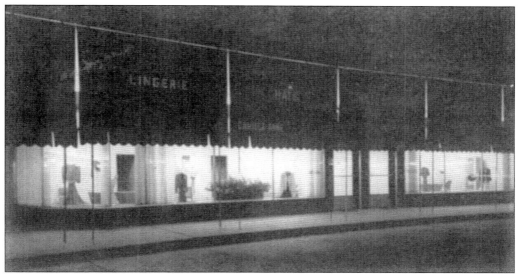

The River Oaks Shopping Center area offers every necessary store for the discerning shopper. An advertisement for the Camilla-Anne Dress Shop stated that its buyers had "just returned with a store full of lovely, sophisticated New York clothes: the shop is air cooled and spacious, lined with mirrors, carpeted with soft restful blue. There are comfortable lounges and chairs, ash trays and cool gold and white walls to make a background for the dresses and suits and lingerie that will be brought out to feast our eyes upon." Some of the other occupants were Louis Chappel, a Belgium portrait painter and decorative artist; Arthur Murray Dance Studio; Gulf, Texaco, Humble, and Shell service stations; River Oaks Theatre; Mrs. Baird's Bakery; three architects, including MacKie & Kamrath; and the Paladium for bowling. (Both, courtesy of James Daniel Becker.)

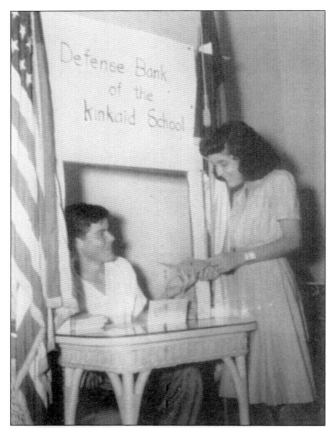

Kinkaid was the oldest independent non-parochial school in Houston and the school for many of the River Oaks children. The school was founded in 1906 by Margaret Hunter Kinkaid, a descendant of one of Stephen F. Austin's Old Three Hundred. During World War II, school pupils sold defense stamps every Friday morning. In this photograph, George Bellows and Jane Ashby do their part in supporting the troops. River Oaks in the 1940s was brimming with school-age children home for the summer. The streets were filled with baseball games, bikes, and jump ropes. It was a safe environment where a child could leave the house after breakfast, come home for lunch, play outside all afternoon, return for dinner, and then catch lightning bugs until bed. It was the American way of life in the most ideal setting. (Both, courtesy of Steve Griffin.)

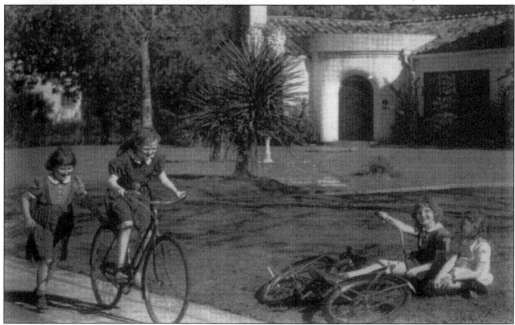

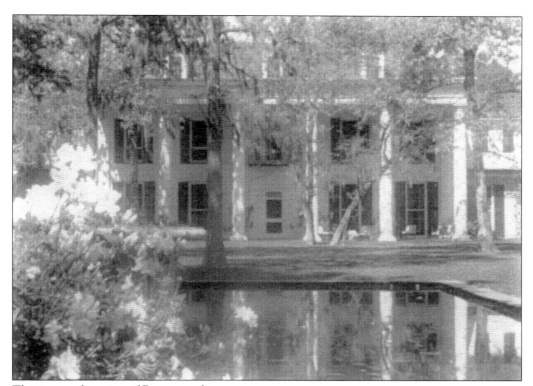

This is a garden view of Ravenna, the home built for Stephen P. Farish and his wife, Lottie Rice Farish, by John F. Staub at 2995 Lazy Lane. The gardens were designed by Ruth London and Ellen Shipman in time for the Garden Club of American 1939 meeting. Lottie Farish, the niece of William Marsh Rice, was a member of the Garden Club of Houston and also of the River Oaks Garden Club, as was Ima Hogg. Farish and his brother, William Stamps Farish, were founders of Humble Oil (Exxon). Later, Stephen Farish started the oil tool firm of Reed Roller Bit. His portrait (right) hangs in the Bayou Club. Signing the charter for the Bayou Club on July 25, 1939, were River Oaks residents Robert D. Farish, Stephen P. Farish, and S.M. McAshan Jr., with Hugo Neuhaus, St. John Garwood, R.D. Randolph, and Harry Wiess. Mike Hogg is credited with helping acquire the property for the club. (Both, courtesy of the Farish family.)

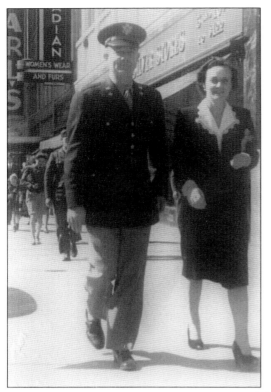

Tex Trammel and his wife, Sue Fondren, enjoy a brisk walk in downtown Houston. Appointed by Otis Massey as Houston's tax assessor and collector, he resigned in order to serve his country. As an Army officer in 1942, he worked in the Army Air Corps recruiting office. Later, Trammel worked for Houston Natural Gas Co., rising from timekeeper to president in eight years. (Courtesy of Sue Trammel Whitfield.)

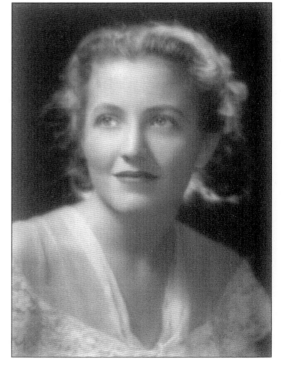

Alice, daughter of David Picton, grew up in River Oaks. In this picture, she is a freshman at Rice University. December 7, 1941 lives large in her memory: "I was leaving the City Library on December 7th, and the newspaper men were yelling out, 'We've been bombed at Pearl Harbor.' It was then that everyone got serious about the war. Many of my male classmates at Rice went to school for combat training and the women began knitting sweaters to show our loyalty." (Courtesy of Alice Picton Craig.)

As World War II drew to an end, major automobile manufacturers were once again willing to act as tastemakers for their franchisees. In 1945, General Motors held a design competition for dealer establishments that Hugh Potter attended (middle row bottom). (Courtesy of Joan Potter Cullinan Hazelhurst.)

In the 1940s, Joan Potter frequented the River Oaks Country Club pool under the instruction of Gil Hitchcock. She won every award imaginable. At the Bayou Club, she rode horses under instruction from Manuel Grayson, who owned a stable on Post Oak Road. Potter commented, "We were always an active family. We rode horses, played tennis and were outdoors all the time. I owned a horse named Mr. Monroe, and also frequently rode 'Sly Ruler,' who was owned by Jimmy Gardener who lived in New York. I was allowed to ride him when he wasn't in town." (Courtesy of Joan Potter Cullinan Hazelhurst.)

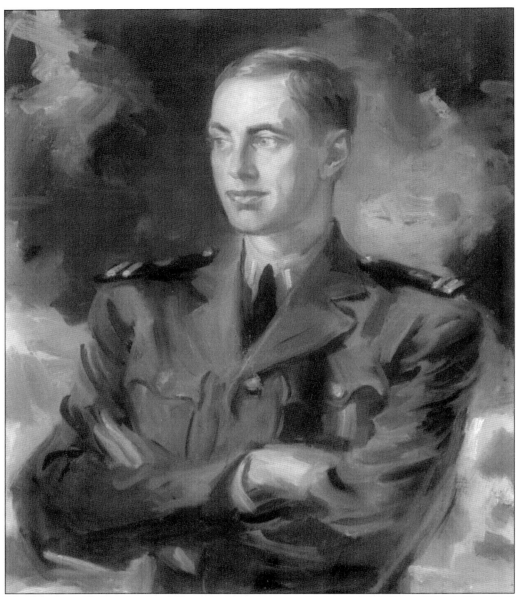

John Hepburn Blaffer, the second but only surviving son of Robert Lee Blaffer and Sarah Campbell Blaffer, was a successful financier. His father was one of the founders of Humble Oil Co., which later became Mobil-Exxon. In this picture from the early 1940s, he is serving in the US Coast Guard. He and his wife, Camilla Davis, from Dallas, had five children. His youngest daughter, Joan, commented: "Dad was very close to his mother, 'Ma.' Every Sunday after lunch we'd go visit her." Ma was Sarah Campbell Blaffer, who instilled philanthropic values in her son. In 1952, Camilla and John donated the east wing of the Museum of Fine Arts in Houston. The commission was awarded to New York architect Kenneth Franzheim. In 1947, Franzheim had drawn plans for the Blaffers' residence years later. (Courtesy of Joan Blaffer Johnson.)

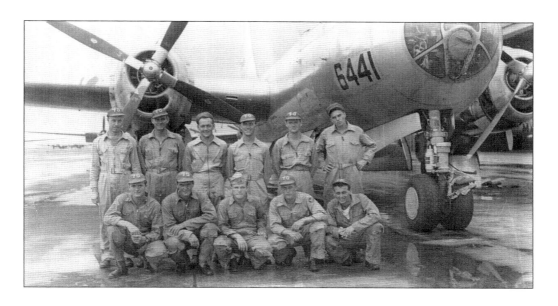

Luke Johnson was born and raised on the Carol Villa plantation, six miles east of Montgomery, Alabama. He joined the Army Air Corps and was assigned to Ellington Field as an instructor. He was assigned to B-29 training at Maxwell Field in Montgomery, Alabama, early in 1945. His brother Wylie Johnson, while aboard the USS *Grainger*, visited Luke on Tinian Island. He commented, "The *Grainger* was an auxiliary cargo ship. It picked up aviation oil in 55-gallon drums at Stockton, CA and delivered it to Tinian the day after Thanksgiving in 1945 for the Army Air Corps. Luke took me on several short flights in the B-29 while the oil was being unloaded." Luke was the son-in-law of Jack Roach, and both families lived in River Oaks and were in the car business. This is the Johnson home at 3839 Inwood Drive. (Both, courtesy of Joan Blaffer Johnson.)

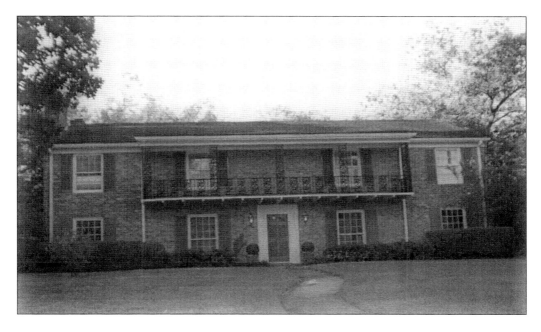

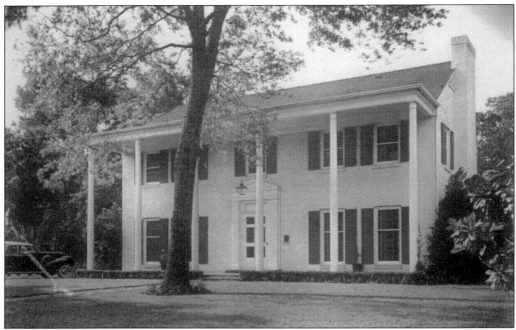

This home located at 2404 Brentwood Drive was built in 1935 in the Colonial traditional style. The house was first designed for Mr. and Mrs. George D. Stevens, and the drawings are dated December 14, 1935. Built for $20,000, it was chosen as one of 36 outstanding houses in *House and Garden*'s special home-building issue of February 1936. In 1946, Mr. and Mrs. Paul S. Benedum purchased it. Later, it was the home of Mr. and Mrs. John Lollar. (Courtesy of James Daniel Becker.)

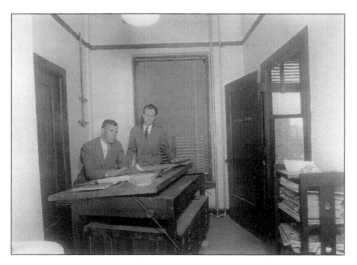

This picture is of Harvin Moore (left) and partner Herman Lloyd in their office in 1934. Moore and Lloyd designed 52 houses in River Oaks and became known for their traditional residential buildings. Harvin Moore designed or remodeled 38 houses from 1942 through 1964. He received commissions for sizable federal projects in Texas, including the Houston Federal Building and Manned Spacecraft Center for NASA. (Courtesy of Barry Moore.)

Robert Joy painted sisters Rosalie (left) and Betty Palmer Bosworth (right) before their marriages to James Ulmer and Oscar Neuhaus. They were daughters of Rosalie Hutcheson Bosworth and husband Laurence Sautelle Bosworth, who lived at 1310 South Boulevard. The Ulmer and Neuhaus families lived in River Oaks with their children for many years. (Courtesy of James G. Ulmer.)

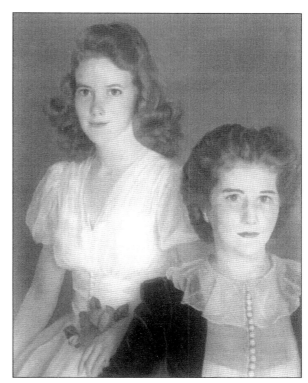

Robert Joy (self-portrait) was a favorite portrait artist among mid-20th-century Houstonians. His portfolio is a virtual historical record of some of the more influential families and their lives. He painted not only Gus Wortham but also his prize bull. While in progress on the painting of brothers Raymond and George Hill, George was in an accident. Undaunted, Joy used Raymond as a literal stand-in for his body. (Courtesy of the Joy family.)

In this 1948 picture, Frank Liddell Jr. is at the Virginia Military Institute. While in the US Air Force, he was injured in an airplane crash. After recovering, Frank studied law at the University of Texas, and he later joined his father's firm. His father, Frank Austin Liddell Sr., wrote the charter for the River Oaks Country Club. He was attorney for Jesse Jones, the *Houston Chronicle*, and Texas Commerce Bank. Pictured below are Ruth (left), George (center), and Lise Putnam. Lise became the wife of Frank Liddell Jr. Their daughter Lise commented, "My parents met at my Aunt Ruth's wedding. She was marrying my father's roommate. My father was a paraplegic who could walk on crutches, bench press 360 pounds, sing and play the guitar. He was very suave and my mom was very cute. They were married seven months after my aunt's wedding." (Both, courtesy of Lise Liddell.)

Maria Burke Butler remembers, "At a dinner party one night, Bishop Quin said 'I want Maria to say the blessing,' so I bowed my head and said 'Dr. Burke's residence!' The table broke out in laughter and Bishop Quin said 'We have God tuned into the right residence.' I was only six years old, and I usually didn't say the blessing." This land on which the home is built was given to GeorgeAnna and Thomas W. Burke Sr. by her mother, Maria "Ria," and her stepfather, Clark Gable, as a wedding present. This home at 3402 Wickersham was designed in 1938 by Talbot Wilson and S.I. Morris. The Burke house has been described as "Architecture truly Texas. . . . The injection of typical Texas life and climate into its architecture brings forth a new term—Gulf Coast Colonial." Pictured playing in the snow are Tom Burke and sister Maria Burke. (Both, courtesy of Maria Burke Butler.)

The wedding reception for the marriage of Michelene Guseman to attorney John Jay Toomey was held in the home of the bride's parents, Tanny C. Guseman and wife Lena DeGeorge, at 1908 River Oaks Boulevard (pictured below). The November 19, 1949, wedding was held at St. Anne Church. From right to left are the bride's nephew, William C. Smith III; the bride's sister Lenora Guseman Smith; the bride, Michelene Guseman Toomey; her sister Ursula Guseman Lusk; and her niece, flower girl Michaelene "Miki" Lusk. The Toomeys have five sons. John Jay Toomey served as executor of the T.C. Guseman estate, managing the real estate portfolio. He currently owns Toyota car dealerships in Houston and San Antonio. Still residing in Houston, both enjoy a second home in Galveston and traveling around the world on cruises. (Courtesy of Michaelene Lusk Norton.)

Four

1950s
The "Happy Days" Decade

By the 1950s, River Oaks residents settled into a wonderful lifestyle. Young children could safely walk to school, roam the neighborhood, ride their horses through Memorial Park, or visit with friends at the River Oaks Drug Store. Older children of the early residents were coming into their own; Allegro was continuing the tradition of debutante presentations. Prospective homeowners came to River Oaks from all parts of the United States. This was the decade when the reputation of the subdivision spread nationwide, and the oil companies, law firms, and medical centers actively recruited new employees. The community remained constant as former child residents, now adults, bought homes in the subdivision. It was a close-knit neighborhood where, within less than a 10-minute drive, one arrived from a downtown office to a peaceful garden home.

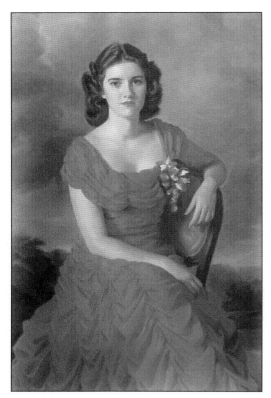

Robert Joy painted Francita Stuart's portrait in 1948, her senior year at the Kinkaid School, when Lyndon B. Johnson was running for the US Senate for the first time. Joy was for LBJ. He put the campaign helicopter in the background of the portrait. Fortunately, he later replaced it with clouds. In 1951, Stuart made her debut with 27 friends at Allegro, the social organization that has presented debutantes since 1925. Her father, Robert C. Stuart, joined Allegro in 1927 at the invitation of Hugh Potter, then chairman. The 1951 debut year was the first time that students from eastern colleges were presented with their Texas friends. After the ball, several left for the airport in their presentation gowns. Two, Cynthia Coates and Judy Sharp, were unable to come to Houston in November, so for the only time in the history of Allegro, there was a second presentation in December. (Both, courtesy of Francita Stuart Ulmer.)

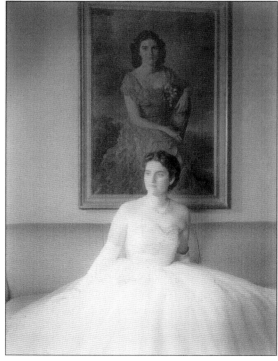

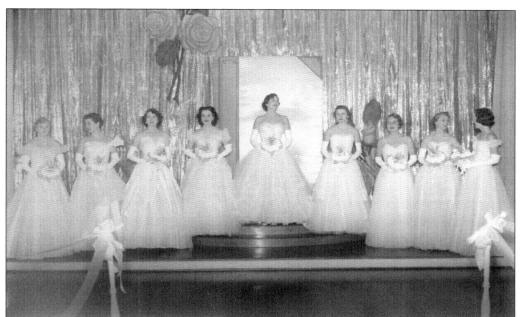

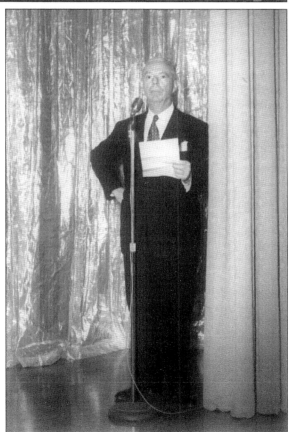

In 1950, these becoming young ladies stand before the silk curtain backdrop with the Allegro banner at their presentation. Included in this presentation was Sue Ledbetter. John Blodgett Davis (right) presented the young ladies at the annual ball, which was held at the River Oaks Country Club. Davis was chairman of the Allegro Committee for a number of years following World War II. He was a courtly, white-haired gentleman. In the early fall of each year, the committee invited presentation-age daughters of Allegro members to a late afternoon cocktail party. The story was that during the party, several members of the committee would invite each of the young ladies to a separate room, where they would be invited to be presented that year. It was referred to in the membership as "hot boxing," although it is doubted that much persuasion was needed. (Both, courtesy of Sue and Paul Gervais Bell Jr.)

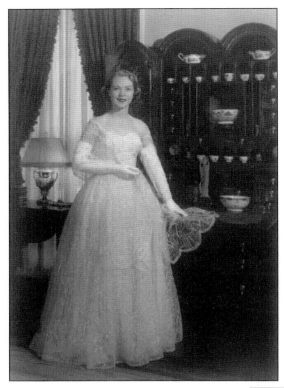

Sue Ledbetter stands in the drawing room of the home of her parents, Dr. Paul Veal and Hazel Ledbetter, at 3508 Inwood Drive. Dr. Ledbetter was a prominent internist and cardiologist. Sue, a sixth-generation Texan on her father's side, posed for this formal debut picture. Her dress was specially made for her by a very creative dressmaker. In 1950, Sue Ledbetter was escorted at Allegro by committee member Thomas D. Anderson. It was at that party that she met her husband-to-be, Paul Gervais Bell Jr. Below, Sue and future husband Gervais enjoy a festive moment. Gervais Bell, the great-grandson of Moses Austin Bryan, was instrumental in the founding of the San Jacinto Museum. Austin, Texas, is named for his family. (Both, courtesy of Sue and Paul Gervais Bell Jr.)

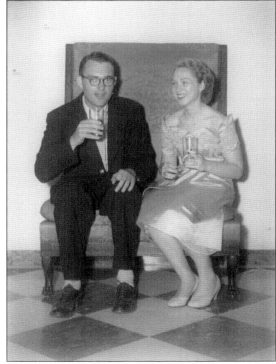

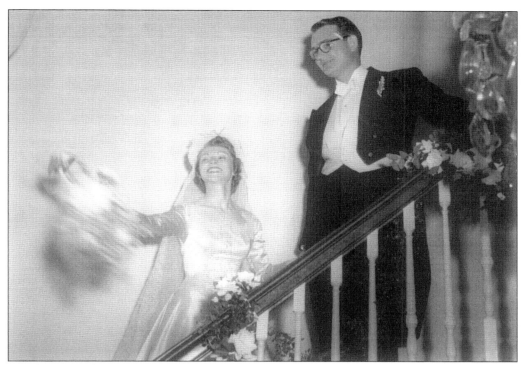

Standing atop the staircase, Gervais Bell watches his new bride, Sue Ledbetter, toss her bridal bouquet. The bouquet toss is an old tradition of uncertain origin where a lucky young woman who catches the bouquet is supposed to be the next in line to be married. This took place on the main stairway in the entry hall of the Ledbetter home. The bouquet was caught by Polly Reed (below), who later married Jay Daniel. Edward Andrews adds to the fun, as men are not usually in line at the bouquet toss. From left to right are Withrow Weir; Edward H. Andrews Jr.; Martha McRae, first cousin of the groom; Polly Reed; and Martha Griswold. (Both, courtesy of Sue and Paul Gervais Bell Jr.)

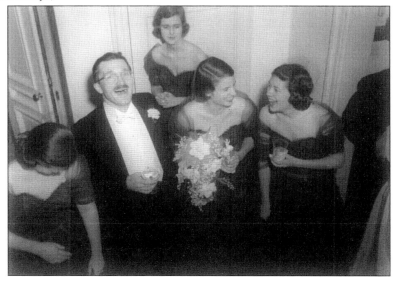

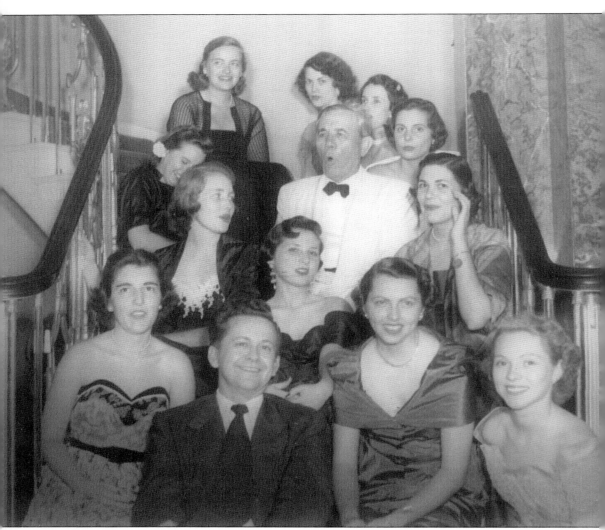

Smiling oilman and philanthropist Hugh Roy Cullen sits on the staircase of the Cullen home with lovely young women who were debutantes of the season. From left to right are (first row) Jacqueline Ehlers, "Louie" the photographer, Caro Ivy, and Sue Ledbetter; (second row) Margaret Wise, Thelma McFarlane, Mr. Cullen, and Mary Bates; partially hidden is Rosalind Saville; (third row) Susan Janse, Virginia Ann Fitch, Harriet James, and Chaille Walsh. In 1938, the Cullens made a contribution to build the Roy Gustav Cullen Building on the new campus of the University of Houston. In 1946, he donated the land that later became Texas Southern University. In 1947, the Cullen Foundation was formed, which today continues to be their philanthropic gift to Houston. (Courtesy of Sue and Gervais Bell Jr.)

Ella Fondren is pictured with Tom Sawyer at the River Oaks Country Club. Sawyer was the popular policeman who oversaw security at club events. Florence "Ella" Cochrum was born in 1880 and lived to be 102 years old. She married Walter Fondren in 1904; at that time, he was a driller. By 1911, the Fondrens were major stockholders of Humble Oil (now know as Exxon). Their philanthropy was extensive. They established the Fondren Lectures in Religious Thought at Southern Methodist University in 1919. They gave major financial support for the construction of a new building at St. Paul's Methodist Church in 1929. Their philanthropic gifts included $1 million for the Fondren Library at Rice University. (Courtesy of Sue Trammell Whitfield.)

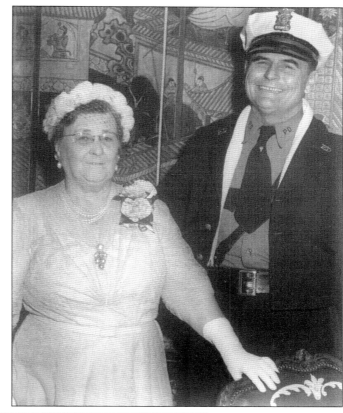

Ella Fondren loved her family and was called "Momo" by her grandchildren. Christmas at Momo's was a special occasion where every grandchild had a stocking hung on the mantel. (Courtesy of Sue Trammell Whitfield.)

Sue is the daughter of Sue Fondren and Tex Trammell and the granddaughter of Walter W. and Ella Fondren. She attended the Kinkaid School, where one of her very best friends was A.J. Carothers (to her left). A.J. grew up to become an American playwright and television writer best known for his work at the Disney studios. Below, Sue is with her future husband, Bill "Whit" Whitfield, and her parents, Sue and Tex Trammell, at her debut in 1954. William ("Bill") Franklin Whitfield was from Wood, Pennsylvania. A graduate of the US Military Academy at West Point, he served in the 40th Bomber Wing as a B-29 pilot in the Korean War. While stationed in San Antonio, Texas, he met Sue Trammell, whom he married on May 29, 1954. "Whit had a marvelous singing voice and had performed with the West Point choir. He had a great sense of humor and was the most organized person I've ever known," Sue Whitfield commented about her husband. (Both, courtesy of Sue Trammell Whitfield.)

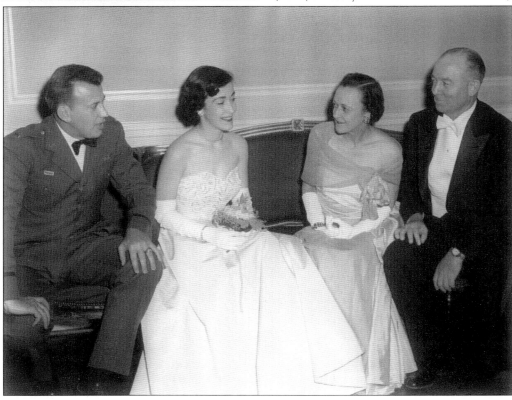

Dillon Anderson, a graduate of Yale Law School, joined the Baker Botts law firm in 1929. He served as managing partner from 1947 to 1952. An Army colonel in World War II, he joined the Eisenhower administration as special assistant to the president for national security in 1955. He was a published writer, a director of Westinghouse Electric Corporation, and a member of the Texas Institute of Letters. Daughter Jill Kyle commented, "In the 1950s we went most weekends to our farm in Independence, Texas. Dad, also known as, 'Popeye' taught me how to drive, fish, and identify certain stars in the night sky. He loved the calm of the country." (Courtesy of Jill Anderson Kyle.)

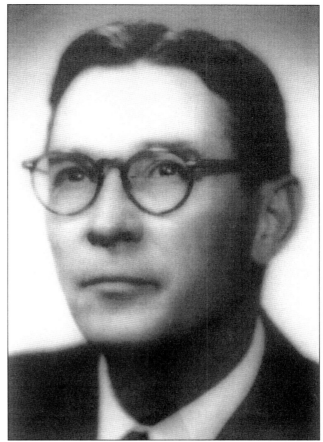

The home at 3414 Del Monte Drive was designed by Birdsall P. Briscoe in the Regency style for Dillon and Lena Anderson. (Courtesy of Joan Blaffer Johnson.)

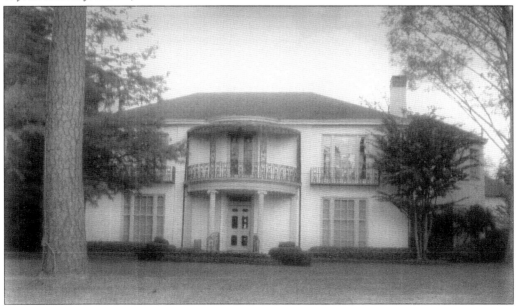

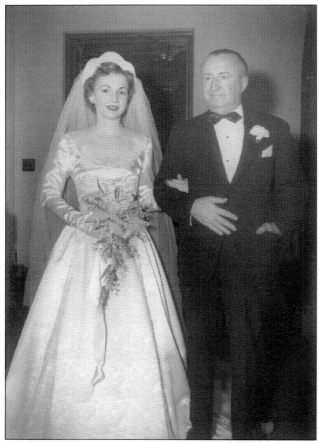

Therese Arnold grew up in River Oaks on the corner of Del Monte Drive and Mockingbird Lane. Like her friend and neighbor Julia Picton, she was from a large family of girls. She graduated from Lamar in 1949 and attended Rice University. Because there were no dormitories for women at Rice then, most girls lived with their parents at home, driving to classes each day. Therese's carpool friends were Julia Picton, Sarah Faulkner, and Erminie Chambers. Therese married Thomas Cain in 1953. He had attended Texas Tech and was a medical student at Baylor in Houston when they met. Her grandfather Edmund B. Arnold was from Galveston. His family had immigrated from Alsace-Lorraine in France to Galveston. He was one of the first orthodontists to practice in Houston. Below is a picture of the Arnold house, located at 3404 Del Monte Drive. (Both, courtesy of Thomas Cain.)

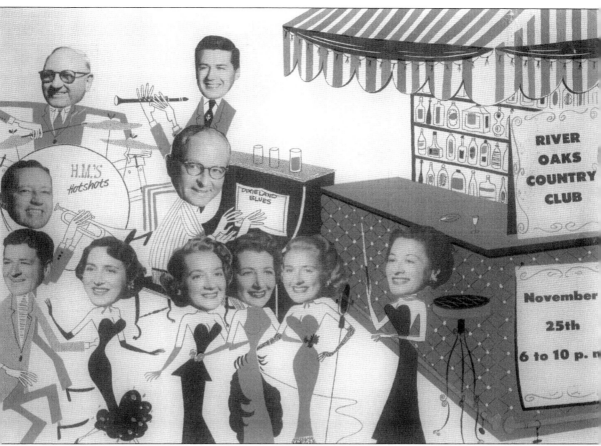

In the late 1950s, producing an invitation to a party and including full-color imagery with photographs was not an easy task. It employed the use of a four-color press, and this particular invitation was nine by 12 inches when folded. It was the event of the season at the River Oaks Country Club, and the Duncans invited their dearest friends. The photographs on the cover are, from left to right, (first row) Mills Duncan, Louise Duncan, Katherine Cummings, Amelia White, Harriet Taft, and Linnie Duncan; (second row) Malcolm Cummings and Lewis White; (third row) Herschel Duncan and Paul Taft. The Dorsey Brothers Orchestra was brought to Houston just for this event, and they played until 3:00 in the morning. It was reported the average fee paid for this type of musical entertainment was $10,000 an appearance. (Courtesy of Sarah Rothermel Duncan.)

The Morris family kept a stable near their home at 3996 Inverness Drive. The parents met at church when they were 12, and a friendship became a marriage in 1939 at Houston's First Baptist Church at Lamar and Fannin Streets. Their daughter Marietta remembers, "Sometimes Daddy cooked breakfast on the grill in the woods for Henry Taub or Governor Hobby and then the men would ride horses to the Polo Club." In the picture below, Carloss Morris stands between his sons, William Carloss Morris III (right) and Malcolm Stewart Morris (left). Eight-year-old Melinda Louise (now Mrs. Glen Ginter) is seated next to Doris Poole Morris, and 14-year-old Marietta (now Maxfield) is seated on the right. Doris Poole Morris had an eye for exquisite interior design and counted designer Doris Duckworth among her friends. (Both, courtesy of Marietta Morris Maxfield.)

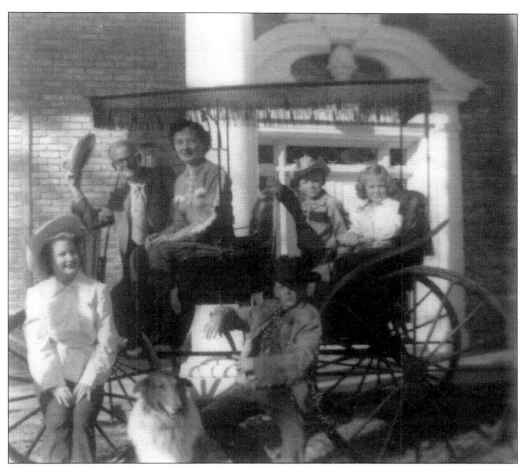

The Morris family was close friends with J. and Betty Pabst, who lived in the neighborhood at 3835 Olympia Drive. J. and Betty surprised Carloss and Doris with an unusual housewarming present (above), a one-horse surrey with fringe on top. Carloss and his brother Stewart acquired other carriages, and Stewart Title developed a carriage collection that was used for community events. Morris was a board member of the Billy Graham Evangelistic Association beginning in the 1950s. Billy Graham was an honored guest in the Morrises' home several times when his crusades brought him to Houston. Doris was cochair of the organization of prayer in Houston for two of the crusades. Carloss Morris served on the board of the Star of Hope Mission for 50 years and today is chairman (in memoriam). (Both, courtesy of Marietta Morris Maxfield.)

The Carlos Hamilton Sr. children are pictured on their way to River Oaks Baptist Church. Their parents were charter members of the church. Early on a Sunday morning, they were asked to pose for this picture by their father, who was an amateur photographer as well as a noted surgeon. From left to right are Lois Jane, Carolyn Ruth, David Peyton, and Carlos Robert Jr. This house is still standing at 3615 Del Monte Drive, and family members still live there. This home was built in 1941 by Dr. Carlos Robert and Berta Denman Hamilton Sr. Three of the Hamilton children still live in Houston, and two are residents of River Oaks currently. Carlos Robert Hamilton Jr. attended Harvard, Rice University, and the University of Texas, graduated from Baylor College of Medicine in 1966, and trained at the John Hopkins Hospital. Later, he became president of the Harris County Medical Society. (Both, courtesy of Carlos Robert Hamilton Jr.)

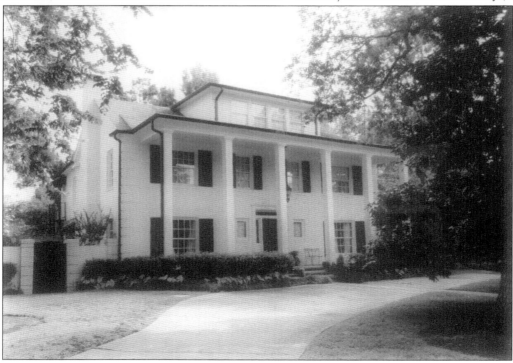

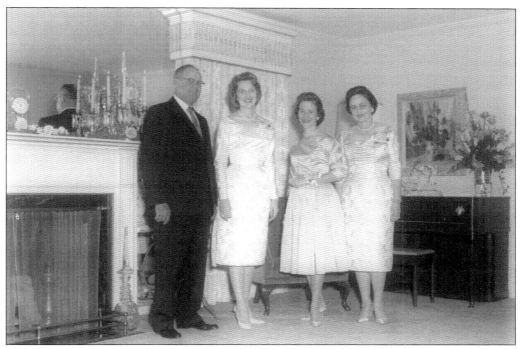

From left to right, Reuben E. (Pat), Carolyn Frances, Sue Marilyn, and Pauline Sims Burton pose in front of their fireplace before attending a debutante tea honoring Carolyn in the fall of 1959. Carolyn graduated from the University of Texas, where she was the Kappa Alpha Theta State Rush chairman; Sue Burton was an honor graduate of Baylor University. Pat Burton worked for Texaco, where he met W.V. Bowles. Bowles left Texaco to start W.V. Bowles and Company and asked Pat Burton to come with him. Bowles died unexpectedly in the early 1940s, and Pat continued to operate the company for the next 30 years. Pauline Sims Burton enjoyed taking the family to their Franklin, Texas, ranch when she was not hosting the River Oaks Blossom Club or many other organizations in her 3713 Chevy Chase Drive home. (Courtesy of Carolyn Burton Hamilton.)

Denman and Ted Moody were as comfortable in black tie as at their ranch. The photograph at left was taken at their ranch in Rocksprings, Texas. The ranch, originally owned by Denman's father, Dr. George Harrison Moody, has been in the family for 100 years. Rhetta Moody McAllister remembered, "On our many long, long car trips to the ranch (eight hours) Mother would entertain the whole family by reading us wonderful Zane Grey novels for hours. She loved to swim, ride horses, and play with us. She had a basketball court built in our back yard on Chilton, and she made our birthday parties such fun with ice cream vendors and pony rides up and down Chilton. Mother was a gifted writer. Among her published works are 'Steps Toward Spiritual Growth' and 'The Sacred Spot.' She must have been an incredible wife, too, as my dad absolutely worshiped her." (Both, courtesy of Rhetta Moody McAlister.)

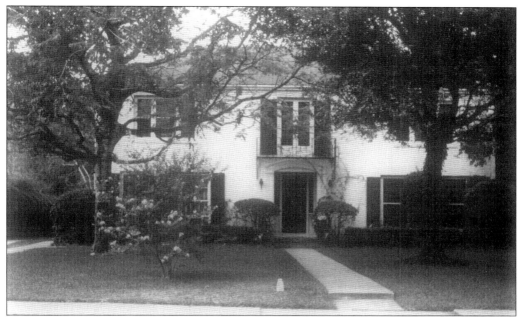

The Moody family lived at 2122 Chilton Road. Denman Moody was a senior partner at the Baker Botts law firm in charge of litigation. Rhetta recalls, "Before we were walking he would put one of us in the saddle with him and take us on round ups. We would happily fall asleep in his arms and feel so lucky to be the one that got to go that day!" Rhetta grew up on the back of a horse. In the 1950s, the area west of River Oaks was perfect for a day's ride. She was a dedicated horsewoman who, in 1956, won the national championship in barrel racing, pictured below. She is quoted as saying, "I spent months training High Spot in the barrel pattern, and he got so good that all I had to do was hang on for dear life!" (Both, courtesy of Bebe Moody Boone.)

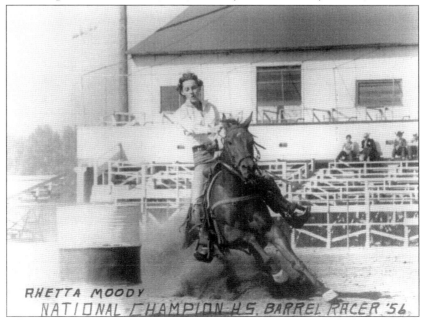

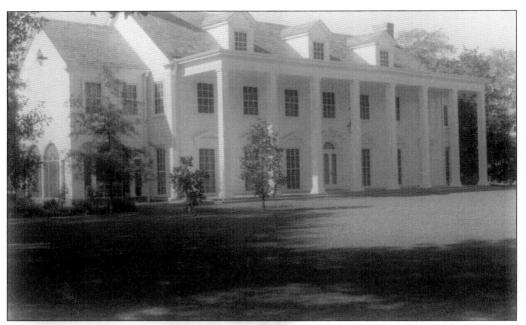

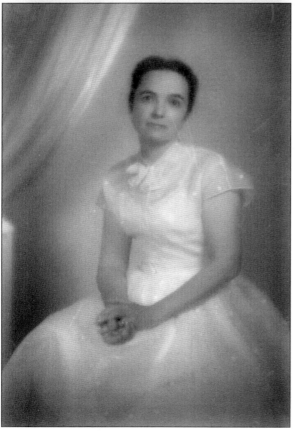

Located at 2004 River Oaks Boulevard and lovingly called "the Mansion" by the Thompson family, this home was built on a two-acre lot in the 1940s. There were five bedrooms, six baths, a wood-paneled library, family room, morning room, upstairs and downstairs kitchens, a solarium, dining room, living room, and children's room. Mayme Elizabeth Jumper Thompson was the wife of Dr. Benjamin Douglas Thompson. Dr. Michael E. DeBakey was her physician and one of her closest friends. He dropped by the Thompson home regularly to discuss wit her the latest advances in medicine and the future of medicine in Houston. Her daughter Mary remembered that DeBakey wept as he informed her and her brother Raymond of their mother's death. At that time, he told the children that their mother was the most intelligent woman he had ever known. (Both, courtesy of Kameron Searle.)

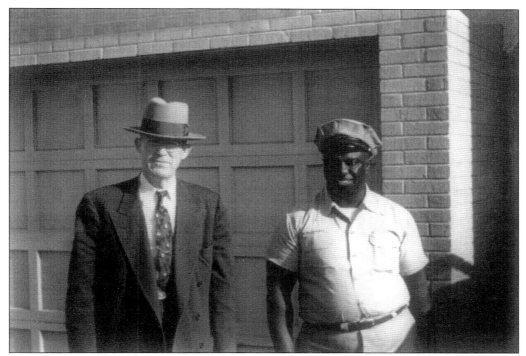

Jessie Russaw worked for Dr. Thompson most of his adult life. In the mornings, he would drive Dr. and Mrs. Thompson to their medical office at 1206 Louisiana Street, now the site of Hyatt Regency Hotel. Then, he would take Mary to the Kinkaid School. Mary Thompson had great style. As a budding young journalist, she kept a record of what it was like growing up on River Oaks Boulevard during the 1940s and 1950s. She photographed everything: her dolls, her home, her friends, and the household servants. She also was the subject of many photographs. When the Mansion was sold, she went into each room and took a photograph to record the moment forever. This image below of Mary looking like a female version of the actor James Dean makes her seem quite timeless. (Both, courtesy of Kameron Searle.)

The Kinkaid School senior class of 1955 is, from left to right, (first row) Virginia Lawhon, Steve Gregory, Lorrie Gose, George Birks, Patsy Keane, and John Cooper; (second row) Susan Hillebrandt, Judy Gill, Sarah Hedley, June Amerman, Sue Houstoun, Julia Moore, Susan Bailey, Lynda Sue Brady, Margaret Kirkham, and Carrie Wingfield; (third row) Charles Brown, Glen Harper, Charles Harter, Harvey Lewis, Charles Pratt, Vernon Frost, Jess Stark, Bobby McCullough, and George

Murray; (fourth row) David Lee, Mary Ann Gay, Flo Burris, Mary Thompson, Sarah Rothermel, Nancy Goldston, Kay Goerner Ketelsen, Suzanne Chinn, Stephanie Wilhelm, Patsy Layne, and David Dyke; (fifth row) George Batten, Darryll Randerson, Glen Solberger, George Clarabut, Bob Brien, Bob Bergdorff, Rob Terry, Tommy Davis, Jim Howard, John Gilbert, Phillip Logan, Harry Thrower, Jimmy Snoddy, and Michael McNeil. (Courtesy of Kameron Searle.)

Little Joan Blaffer was delighted with this darling car. It was a 1950s version of the pressed steel–body pedal car and made a fine birthday present for a four year old. No matter where the Blaffer family was at the time of a family member's birthday, it was celebrated. The bottom picture was her sixth birthday party, and although there are 14 children gathered at the cake, one can tell by the number of plates that this was a grand event. At the River Oaks Country Club, little girls wore their best lace party dresses, and while the parents went to their own room to visit, the children were served cake and cared for by employees of the facility. Much like birthday parties in the 1930s, the guest list was as large as the neighborhood. (Both, courtesy of Joan Blaffer Johnson.)

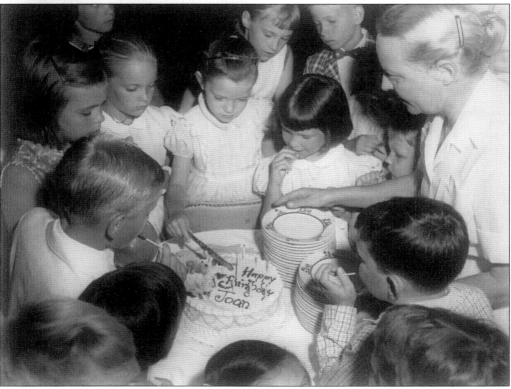

Camilla Davis Blaffer, a member of a prominent Dallas family, was a Phi Beta Kappa graduate of Wellesley College and the mother of five children. Joan Johnson remembers, "When I was little they'd have weekly dinner parties. A regular attendee, David Moncrief would bring his delicious additions to the dinner. Velma Jefferson was our regular cook but when family or friends came to Houston, we entertained with Southern hospitality." Kenneth Franzheim drew the plans for 2 Briarwood Court as a wedding gift to John and Camilla. Franzheim is best known for designing nonresidential buildings like Foley's and the Humble Building. Below is a Humble Oil Christmas gathering; Sarah Campbell Blaffer is in sunglasses, and other guests include Libbie Rice Farish, Ginny Rotan, John Blaffer, Lula Campbell, W.T. Campbell, Margaret Elkins, Olga Wiess, and Effie Hunt. (Both, courtesy of Joan Blaffer Johnson.)

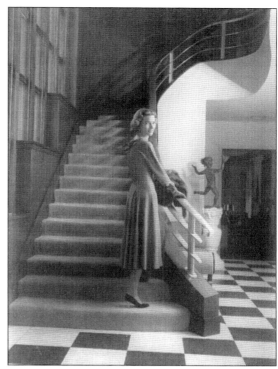

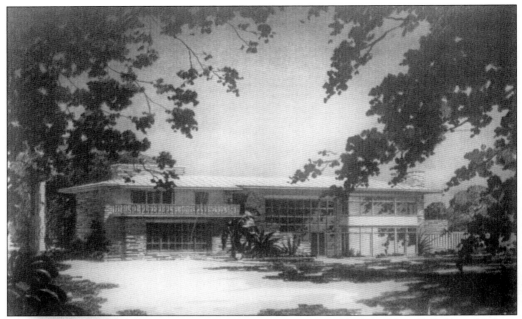

Alfred C. Glassell (left) and John H. Blaffer (right) attended the 1959 Roman toga party given for Joanne King (Herring) on her 30th birthday. *Life* magazine as well as Houston media covered the event. Joanne Herring commented, "So much has been made about this party, but actually there were only 50 guests, and it was tame, not what the media coverage would lead you to believe." Everyone in attendance wore Roman costumes and a few of the 50 guests included Anne and W. Browne Baker III, Jane and Robert Mosbacher, Suzanne and Frank Nelms, Sandra Whitney Payson, and Claude and Jake Williams, the Kress heirs. Joan Blaffer Johnson recalls, "My father was a very strong man and when you were with him you felt very safe. This picture makes me happy to see such good friends toasting each other." Above is a picture of 2 Briarwood Court, home of John and Camilla Blaffer (Both, courtesy of Joan Blaffer Johnson.)

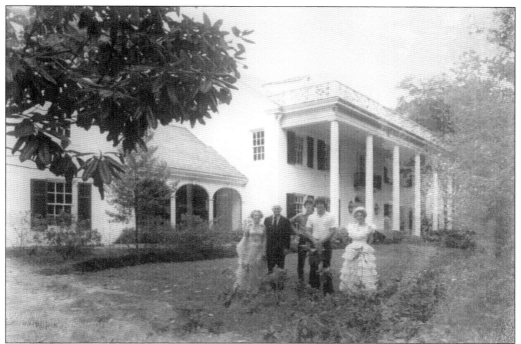

William Emmett Sampson owned the Texas Sand and Gravel Construction Company. His company built this house in the 1930s. Sampson was on the board of Baylor University and a founder of Houston Baptist University. Joanne King Herring remembers, "My grandfather's house had a 50-foot staircase going down to Buffalo Bayou. Even so, during the flood of 1935, the water in the library was up to an adult's knees" Pictured in front of the home are, from left to right, Dunlop Johnson, Maelen Johnson, Beau King, Robin King, and Joanne King Herring. "My father as an engineering consultant worked abroad most of my younger years; that is why I lived with my grandparents." (Courtesy of Joanne King Herring.)

Nancy Welsh Robbins (left), daughter of Dr. Hugh Welsh, who lived at 3465 Inwood Drive and was doctor for the Rice University football team, joins Dr. Denton Cooley (center) who lives on Del Monte Drive and is the friend of her husband, Dr. Horace Robbins. With Joanne King (Herring), at right, they are at a party benefitting the Houston Zoological Society. (Courtesy of Nancy Welsh Robbins.)

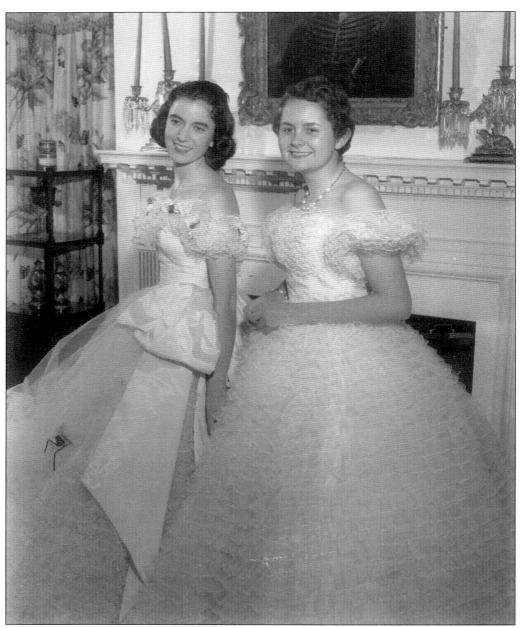

Mary Thompson (left) and Janice West were given a sweetheart dance by Dr. Benjamin Thompson. The society column reported, "Two lovely young ladies soon to become graduates will be honorees tonight at a sweetheart dance at River Oaks Country Club from 9 to midnight. A sweetheart scene will be used for the decorations. The bandstand where Albino Torres and his orchestra play will be decorated with white and gold glitter hearts and red carnations." There were 500 in attendance. Janice West wrote, "Dear Dr. Thompson, I just never did get to tell you all I wanted to tell you about the dance—in fact I don't believe I have the words to express just how I feel inside. It was truly the nicest dance I have ever attended. I'm sure I know now how Cinderella felt at the ball." (Courtesy of Kameron Searle.)

Five

1960s
A Changing World

The 1960s saw the end of the Eisenhower administration and the short romance of Pres. John F. Kennedy's "Camelot." The building of the Berlin Wall caused President Kennedy to call up the Reserves, and many River Oaks men and women, like attorney and Naval Reservist Philip Koelsch, were called to serve. When Lyndon B. Johnson became president, River Oaks resident Jack Valenti was called to be on his staff. NASA had been launched, and astronaut Alan Shepard lived on Chevy Chase Drive. The Vietnam War called up young men and women, protests were held nationally, and the busing of students from around Houston was implemented. It was a crucial time of change for Houston, and the residents of River Oaks were solidly planted within the restriction-enforced subdivision founded by Hugh Potter and the Hogg brothers.

A favorite Halloween custom was trick or treat at the home of Helen Trevor Vietor on Sharp Place. She and friend Sue Brooks Green pose as witches on the roof and deliver candy below. Mrs. Vietor is the founder of the highly regarded Pooh Corner, which has been offering education to preschool children for more than 50 years. (Courtesy of Joan Blaffer Johnson.)

This charming early River Oaks house exemplifies what the Hoggs and Hugh Potter wanted for their subdivision. It is located at 1805 Sharp Place on one of the circular courts similar to those on Stanmore Drive where children could play without crossing a street. For many years, it has been the home of Hart and Sue Green where their children, Beth and Leslie Green, who attended St. John's School, grew up. (Courtesy of Hart and Sue Green.)

The Denman Moody family had a tradition of using the nickname "Teddy" or "Ted" for Edna. Teddy Lewis moved to Austin, Texas, to attend the University of Texas and met and married Denman Moody. The couple made their permanent home in Houston after Denman graduated from UT Law School. The couple had a daughter and promptly named her Teddy Lewis Moody. They had three more children; from left to right are Rhetta, Denman, Ted, Denman Jr., and Bebe. Daughter Teddy passed away quite young. Her siblings remained close and every year celebrated their parents' anniversary with a themed party. This photograph was taken before a "Mexican" party. (Courtesy of Denman Moody Jr.)

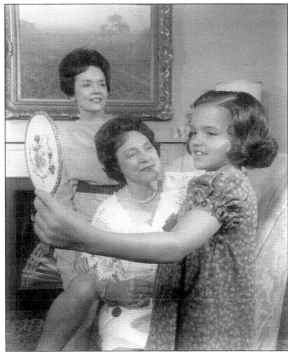

The picture at left, taken by the *Chronicle* in the mid-1960s, shows three generations of Teddys together from an article that honored families who had lived in Houston for several generations. (Courtesy of Denman Moody Jr.)

Will Hogg formed the Forum of Civics to develop a plan for Houston's public spaces. Housed originally in this building, a former schoolhouse owned by Hogg, the name continued after the River Oaks Garden Club (organized in 1927) acquired the property for its headquarters in 1942. With the Garden Club of Houston, it sponsored the 1939 Annual Meeting of the Garden Club of America, where guests from all over the United States saw many River Oaks houses and gardens. In addition to the annual spring Azalea Trail, the fall Pink Elephant Sale, started in 1951, provides funds for club projects like the maintenance of the Bayou Bends Gardens, begun in 1961. Seen here in a promotional picture for the sale, first chaired by Faith Bybee (standing on the right), are Peggy Hamill, Eloise Frame, and Marian Britton. (Above, courtesy of Jim Fisher; below, courtesy of James Daniel Becker.)

Christmas at the Mastersons is pictured in 1960. Standing in the background is Isla Reckling; seated is grandmother Isla Carroll Sterling Turner holding baby Christiana Reckling; and young Randa Reckling is standing next to Carroll and Harris Masterson, who led the movement to raise the Houston arts scene to par with other major US cities. Their home, Rienzi (below), was named for Harris Masterson's maternal grandfather, Rienzi Melville Johnston, founder of the *Houston Post*. John F. Staub designed the home, and Ralph Gunn designed the gardens that are now maintained by the Garden Club of Houston. The house and gardens are on the annual River Oaks Garden Club Azalea Trail. Rienzi served as an elegant center for many parties and dinners and is now part of the Museum of Fine Arts in Houston. Carroll and Harris Masterson were a couple who devoted their lives to enhancing Houstonians' quality of life. (Both, courtesy of Isla Reckling.)

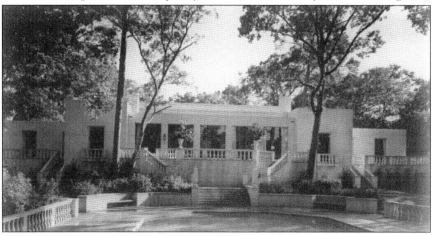

In 1968, Frances "Franny" Koelsch (left), held by her nurse, Mary Long, was baptized at Christ Church Cathedral by the Very Reverend Robert T. Gibson. Outside the church with Frances are her brother Robert and grandfather Robert Stuart. She is the daughter of Rear Adm. and Mrs. Philip Koelsch, who lived at 1916 Kirby Drive for many years. (Courtesy of Christ Church Cathedral Archives.)

Lee Hull (Cochran) was raised at 3209 Locke Lane and was the oldest daughter of Dr. John and Leila Norris Hull. Dr. Hull practiced internal medicine in an era when doctors made house calls. Lee commented, "I'd go to the hospital with Daddy on Sunday to make his rounds. He believed in treating the whole patient, not just the symptoms." Lee is holding her daughter Leila Hull Cochran, the oldest of her children with Robert Palmer Cochran. Leila, born in 1968, became a sixth-generation Houstonian. (Courtesy of Laura Cochran Savage.)

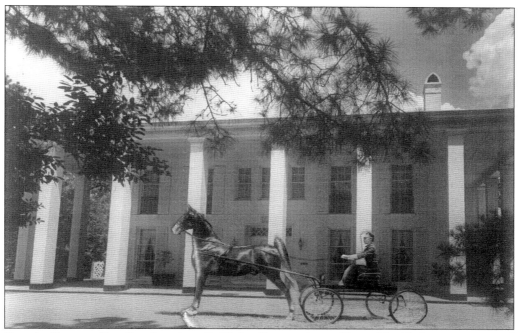

Dorothy Howe and her fine American Saddlebred harness horse, King of the Highway, are pictured in front of her home, Legend, in 1960. Howe and King of the Highway competed at Houston's Pin Oak Charity Horse Show and other southwest circuit events.

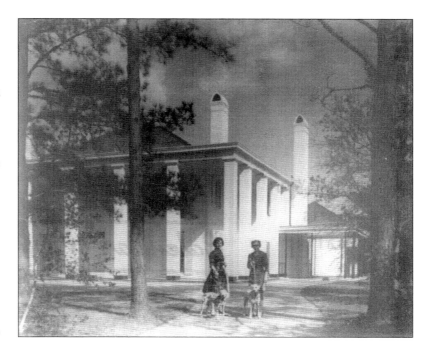

In February 1960, the Museum of Natural History (now the Museum of Natural Science) Guild held its annual Kitchen Tour to raise funds for the museum. Pictured are Mrs. Robin Elverson (left) and Mrs. Knox Briscoe Howe in front of Dorothy Howe's home, Legend, one of the stops on the tour. (Courtesy of Dorothy Knox Howe Houghton.)

Dorothy Knox remembers, "Robert Joy painted my portrait my senior year at Lamar High School. After school, I would don my evening gown at his studio on Harold Street behind Lanier Junior High School. As I watched my hair change color on the canvas at each sitting, he regaled me on his favorite subject, liberal politics. Most of his patrons were political conservatives, and he loved goading them. My mother and I showed American Saddlebred horses at Houston's Pin Oak Charity Horse Show and around the country. My mother asked Mr. Joy to include our horse, Faraway Starr, in my portrait. Stumped by the challenge of combining the horse and the evening gown, Mr. Joy settled on painting the horse on the distant landscape. With characteristic humor, he told me he wanted to enter my portrait in an exhibit, entitle it *Portrait of Faraway Starr with Girl on Landscape*, and invite my mother." (Courtesy of Dorothy Knox Howe Houghton.)

Before Sunday school at Christ Church Cathedral, Elizabeth Ulmer, left, and her older sister Ann sit in the cloister of the Bishop's Garden awaiting their friend Beth Green (1805 Sharp Place). Both Ann and Elizabeth attended River Oaks School before joining Beth and neighbor Susan Garwood (3707 Del Monte Drive) at St. John's School. They are the daughters of James and the late Rosalie Bosworth Ulmer. (Courtesy of Francita Stuart Ulmer.)

After church at River Oaks Baptist, the Townes-Pressler family (2133 Pine Valley Drive) gathered every Sunday for lunch. From left to right are (first row) Molly, Townes Jr., Terry, Jean, and Anne Pressler; (second row) Bette, Mrs. Herman Pressler Sr., Mrs. Herman Pressler Jr., Mrs. E.E. Townes, and Nancy Pressler; (third row) Townes Pressler Jr., Herman P. Pressler Jr., Paul IV, and Paul III. (Courtesy of Judge Paul Pressler.)

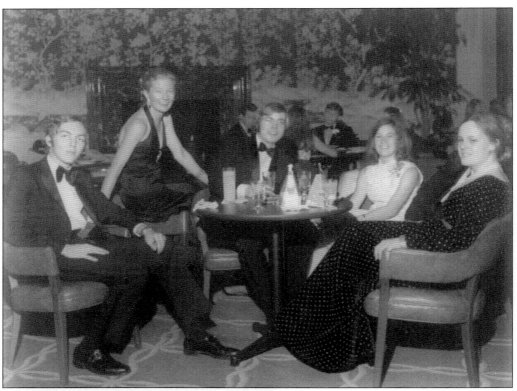

Relaxing in the ballroom of the new River Oaks Country Club are, from left to right, Angus McReynolds, Camilla Blaffer, Harry Hurt III, Barbara Briggs, and Marisol de la Beggassiere. Camilla makes sure her French niece Marisol meets her Texas counterparts. Marisol's parents are Joyce Blaffer, the youngest daughter of Mr. and Mrs. Robert Lee Blaffer, and Marquis Jacques de la Beggassiere. Marquis's grandfather built the Suez Canal. Harry Hurt III, a Harvard freshman, would later become a distinguished writer. Camilla and John Blaffer, in the picture at left, are at a New Year's Eve party. The little red motorcar belonged to Joan, was called *Beebee*, and was powered by a gasoline lawn mower engine. (Both, courtesy of Joan Blaffer Johnson.)

The theme of this party was the 12 days of Christmas, and this photograph shows a hand-illustrated invitation cover design. Twelve senior girls invited their friends, and the evening began with dancing and culminated in a midnight breakfast. During the Christmas season, it was not unusual for young people to attend four parties a week. This Christmas party held in 1969 was for high school seniors. The 12 honorees invited more than 300 guests. In the picture below, Joan Blaffer and her escort, Mason Granger (right), stand in the receiving line at the River Oaks Country Club. Mason Granger, from New York, attended Choate School in Wallingford, Connecticut. No doubt he remembered Harry Hurt graduating in the spring. Mason's father, David, owned a seat on the New York Stock Exchange and was a great friend of the Hurts. It is not surprising that their sons should attend this dance together. (Both, courtesy of Joan Blaffer Johnson.)

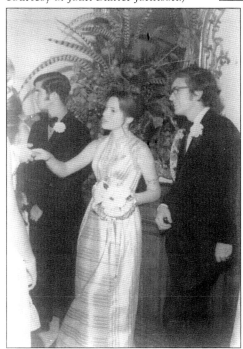

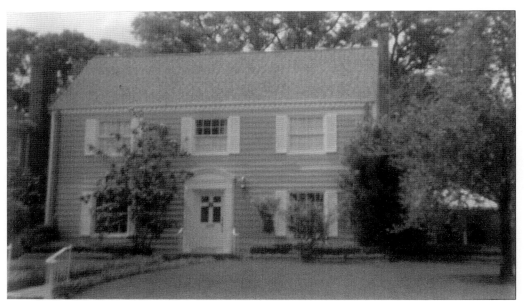

Betty Ann Morris and Dr. Claude Burke Purdie owned this house at 2228 Del Monte Drive in the 1960s. The architectural firm of Moore and Lloyd designed it in 1934. Dr. Purdie worked with his uncle Dr. Tom Burke in the Drs. Burke and Purdie Clinic. David Purdie commented, "We had the best Kool-Aid stands! We would offer Richie Rich comic books, if the customer would purchase three cups! Craig Murphy and I built a fort in the rafters of the garage at our house on Del Monte. It had everything, including patchwork-scrap carpeting, electric fans and a television." The clown-themed birthday party shown below was held at Peppermint Park. From left to right are Ellen Blazek Kathcart, Bill Workman, Craig Murphy, birthday boy David Purdie, and Claude Burke Purdie Jr. (Both, courtesy of David Purdie.)

The Hamilton-Burton children had both grandparents and parents who were residents of River Oaks. Norma Josey (standing) was a lifelong companion to, from left to right, Carlos R. Hamilton III, Peggy Sue Powell, Patricia Frances Hamilton, and Frances Ann Powell. Texas roots run deep in this family line, as Capt. James A. Baker of Rice University fame was a nephew of the their great-great-grandfather Dr. John Baker. (Courtesy of Carlos Robert and Carolyn Hamilton Jr.)

Lunching at the River Oaks Country Club was quite a treat. Joan Blaffer and her brother Lee attended this special lunch each year after hunting for Easter eggs. The children were led to special long, low tables that were covered with cloth. Their father, John Blaffer, caught the children off-guard in this candid photograph. (Courtesy of Joan Blaffer Johnson.)

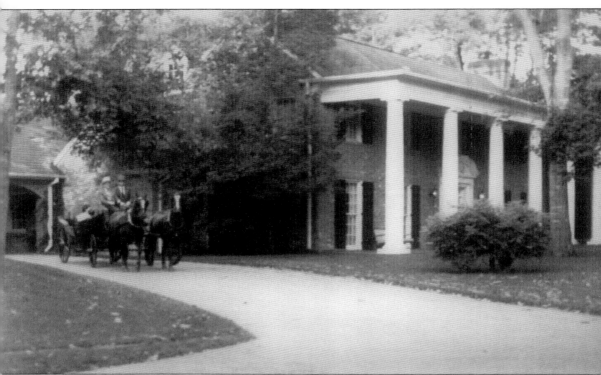

In the late 1940s, Doris and Carloss Morris acquired 6.04 acres in the Tall Timbers section of River Oaks. Bordered by Buffalo Bayou and, on the south property line, a deep ravine, they met the challenge of access by building a private road over the ravine with a 60-foot pipe under it to carry the water. This is their home, located at 3996 Inverness Drive. The Luke Johnson home was nearby, and they shared a stable. Carloss negotiated a long-term lease of railroad right-of-way, which he used to pasture his horses; he piped in water and built a temporary barn. Architect Kelly Gaffney designed the house plans dated 1951. This picture, taken in the 1960s, shows a timeless image of the River Oaks lifestyle. (Courtesy of Marietta Morris Maxfield.)

Index

Allegro, 87–89
Ball, 10–13, 18
Bayou Bend, 38–40
Bell, 90, 91
Blaffer, 38, 80, 108–110, 122, 123, 125
Brill, 74
Briscoe, 34, 38, 40, 95, 119
Brooks, 114
Buffalo Bayou, 8, 9, 17, 22, 26, 27, 40, 58, 61, 111, 126
Burke, 68, 69, 85, 124
Burton, 101, 125
Clayton, 34, 35
Country Club Estates, 10, 11, 13–17, 24, 26–28, 36, 37, 55
Cullen, 70, 92
De la Beggassiere, 122
DeGeorge, 86
Duncan, 63, 64, 97
Farish, 13, 77
Fondren, 78, 93, 94
Franzheim, 80, 109
Gable, 68, 69, 85
Georgian gates, 2, 30, 32
Guseman, 86
Hamilton, 100, 125
Hare, 8, 25, 26
Herring, 110, 111
Hogg, 7, 8, 15–17, 19–25, 27, 28, 37–40, 43, 69, 77, 113, 114, 116
Holcombe, 25, 70
Homewoods, 27, 38
House, 10, 11, 13, 18, 25
Joy, 45, 83, 88, 120
Kamrath, 66, 67, 75
Kinkaid, 76, 88, 94, 105–107
Kipp, 11, 25, 26
Kirby Drive, 8, 23, 44, 47, 118
Koelsch, 113, 118
Ledbetter, 51, 89–92
Lollar 18, 82
Masterson, 117
McAshan, 35, 72
Mellinger, 39, 51, 55–57
Moore, 51, 82, 107, 124

Morris, 51, 85, 98, 99, 124, 126
Neal, 62, 63
Nichols, 32
Oliver, 37, 49
Pearl Harbor, 78
Picton, 18, 36, 37, 51, 62, 78, 96
Potter, 7, 8, 15, 17–23, 25, 27, 28, 29, 32, 42, 43, 58, 70, 71, 73, 79, 88, 113, 114
Pressler, 52, 53, 121
Proctor, 40
Quin, 48, 73, 85
Reynolds, 9, 11, 126
Riddle, 42, 46
Rienzi, 117
River Oaks Boulevard, 8, 12, 28, 29, 86, 104, 105
River Oaks Corporation, 28, 30, 32, 33, 36, 42, 43, 46, 53, 54, 57, 57, 73
River Oaks Country Club, 11, 13, 20, 22, 24, 27, 33, 34, 40, 64, 79, 84, 89, 93, 97, 108, 112, 122, 123, 125
River Oaks Elementary School, 8, 41
River Oaks Garden Club, 39, 49, 77, 116, 117
River Oaks Golf Course, 14, 62
River Oaks Shopping Center, 75
River Oaks Theatre, 70
Ross, 13, 14
Rothermel, 64, 65, 107
Sawyer, 93
Shepherd Drive, 23
St. Thomas High School, 61
Staub, 2, 12, 13, 30, 36, 38, 40, 44, 51, 55, 57, 62, 63, 77, 117
Strake, 59–61
Stuart, 47–52, 88, 118
Thompson, 64, 104, 105, 107, 112
Trammell, 94
Troon Falls, 31
Troon Road, 31, 58
Ulmer, 43, 83, 121
University of Texas, 20, 21, 37, 84, 100, 101, 115
Vietor, 114
Wiess, 22, 77, 109
Widee, 17, 18
Womack, 13
World War II, 29, 71–86, 89, 95

Discover Thousands of Local History Books
Featuring Millions of Vintage Images

Arcadia Publishing, the leading local history publisher in the United States, is committed to making history accessible and meaningful through publishing books that celebrate and preserve the heritage of America's people and places.

Find more books like this at
www.arcadiapublishing.com

Search for your hometown history, your old stomping grounds, and even your favorite sports team.

Consistent with our mission to preserve history on a local level, this book was printed in South Carolina on American-made paper and manufactured entirely in the United States. Products carrying the accredited Forest Stewardship Council (FSC) label are printed on 100 percent FSC-certified paper.